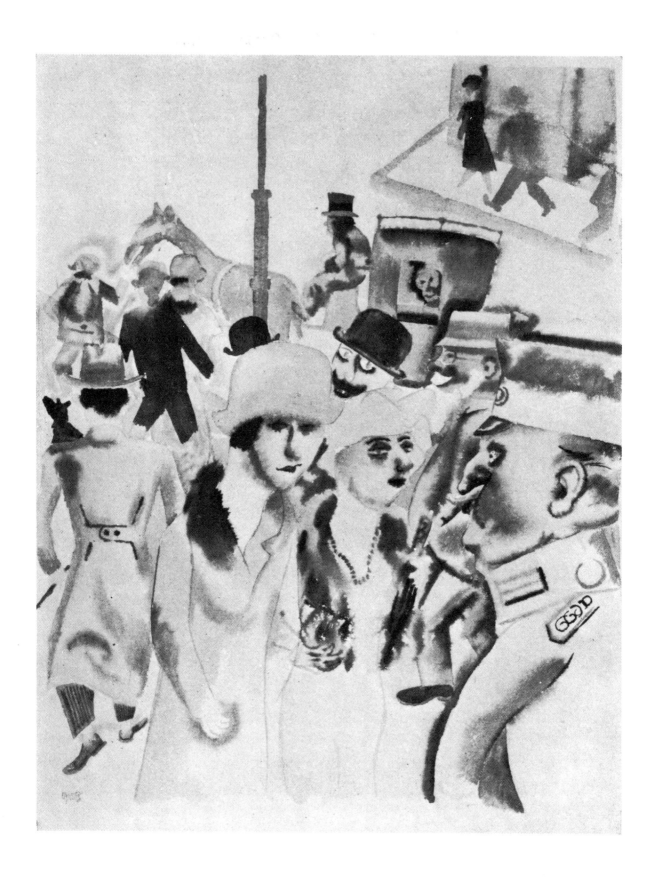

On the job
Berufstätig

LOVE
ABOVE
ALL
and Other Drawings

ÜBER ALLES DIE LIEBE and DIE GEZEICHNETEN

120 WORKS BY
GEORGE GROSZ

DOVER PUBLICATIONS, INC.
NEW YORK

Published in Canada by General Publishing Company, Ltd.,
30 Lesmill Road, Don Mills, Toronto, Ontario.
Published in the United Kingdom by Constable and Company, Ltd.

This Dover edition, first published in 1971, is an unabridged republication of the following two volumes: *Über alles die Liebe: 60 neue Zeichnungen*, originally published by Bruno Cassirer, Berlin, 1930; and *Die Gezeichneten: 60 Blätter aus 15 Jahren*, originally published by the Malik-Verlag, Berlin, 1930 [already available late 1929].

The artist's preface to *Über alles die Liebe* and the captions of both volumes have been translated specially for the present edition by Stanley Appelbaum.

The original German publication of *Die Gezeichneten* was a collection including previously unpublished drawings, drawings which had appeared in portfolios and magazines, and drawings previously published in the volumes *Abrechnung folgt, Der Spiesserspiegel, Ecce homo* and *Das Gesicht der herrschenden Klasse*.

The publisher and translator are grateful to Dr. Ernest Hamburger of the Leo Baeck Institute, New York, who supplied valuable background information for some of the captions.

International Standard Book Number: 0-486-22675-1
Library of Congress Catalog Card Number: 78-121583

Manufactured in the United States of America
Dover Publications, Inc.
180 Varick Street
New York, N.Y. 10014

List of Illustrations

DIE GEZEICHNETEN (THE MARKED MEN)
[The dates of the drawings are given along with the German titles.]

The two small untitled drawings on this page and the next originally appeared on the last page and back cover of *Die Gezeichneten*.

THE ARTIST'S PREFACE

LOVE ABOVE ALL. The title shows that the subject here is interpersonal relations. Fine, but don't expect my drawings to illustrate any run-of-the-mill lovers' idyll. Realist that I am, I use my pen and brush primarily for taking down what I see and observe, and that is generally unromantic, sober and not very dreamy.

The devil knows why it's so, but when you take a closer look, people and objects become somewhat shabby, ugly and often meaningless or ambiguous. My critical observation always resembles a question as to meaning, purpose and goal . . . but there is seldom a satisfying answer. So in place of it I put down my graphic marks. Sober and with no mystery! So people pass each other by . . . blank spaces remain where they were; I attempt to capture this with the means I am given.

Regulations and rational plans are made; hurrah for progress, human relations in general and reproduction in particular; Vera Figner's memoirs and Magnus Hirschfeld's books on morals share the bedside table with van de Velde's *Calendar of Love*.

I raise my hand and hail the eternal human law . . . and the cheerful good-for-nothing immutability of life!

GEORGE GROSZ

[Translator's note: Vera Figner was a Russian revolutionist,
Hirschfeld was a German psychiatrist.]

[Quotation originally placed at the beginning of *Die Gezeichneten:*]

And God blessed them, and God said unto them,
Be fruitful, and multiply, and replenish the earth, and
subdue it

Genesis 1 : 28

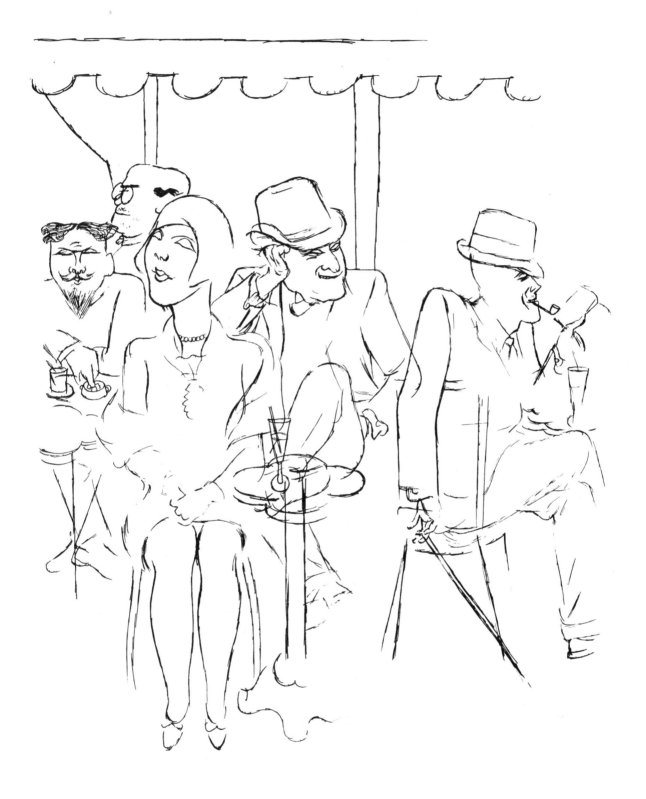

Spring arrives
Frühlings Anfang

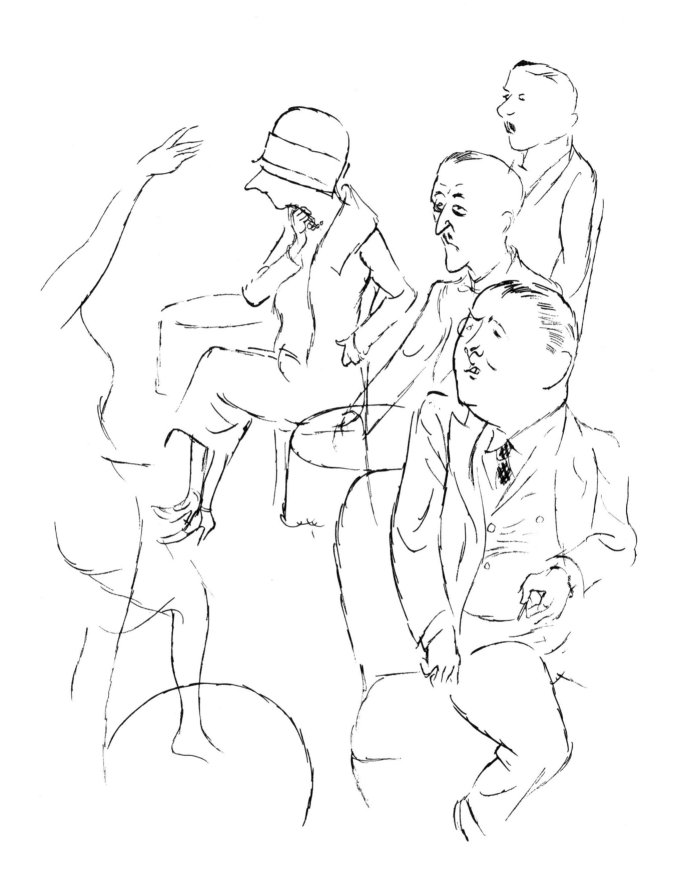

Of good family
aus gutem Hause

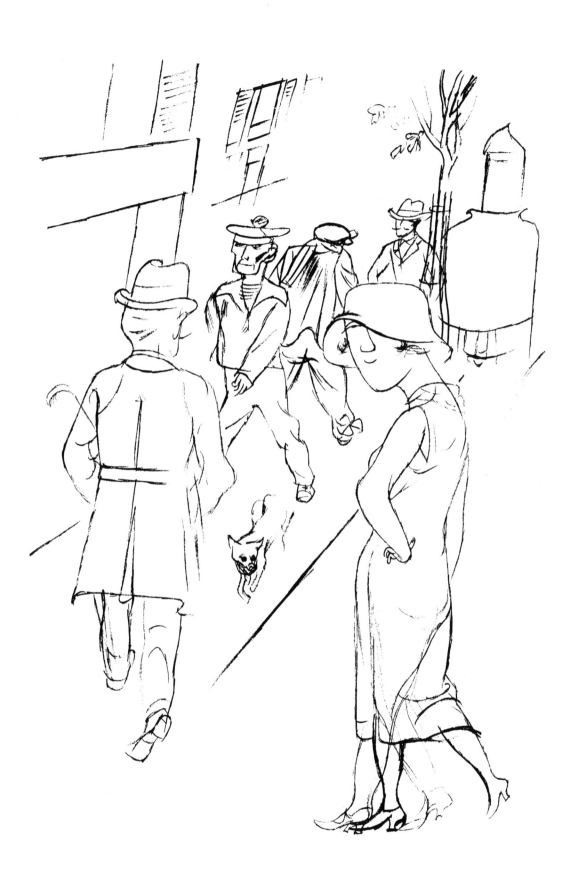

Second income
Nebenverdienst

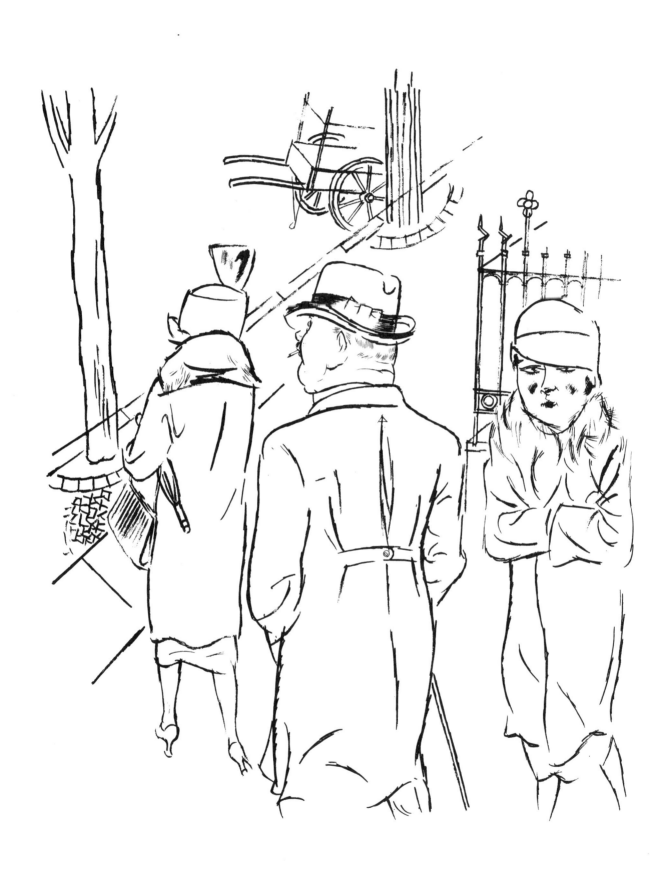

In form
in Form

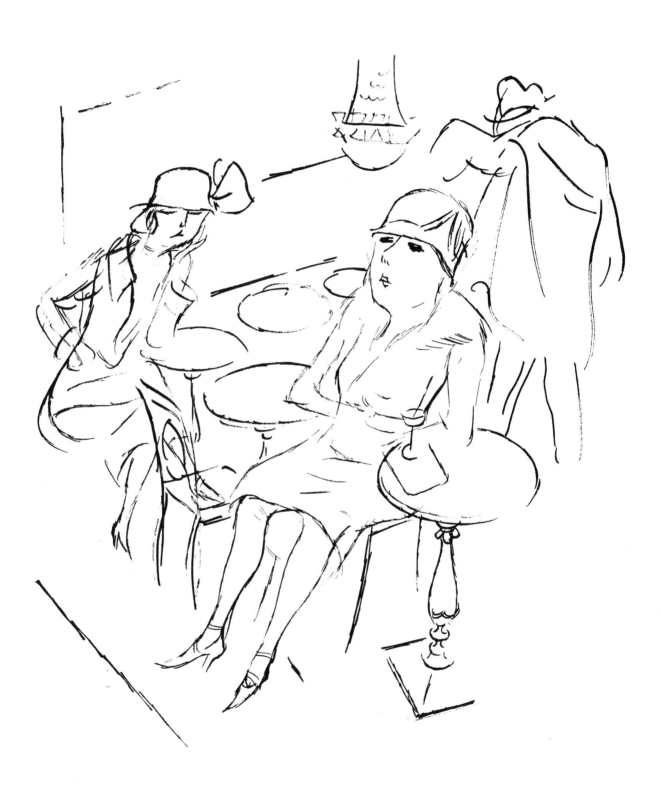

They don't sing any more
die nicht mehr singen

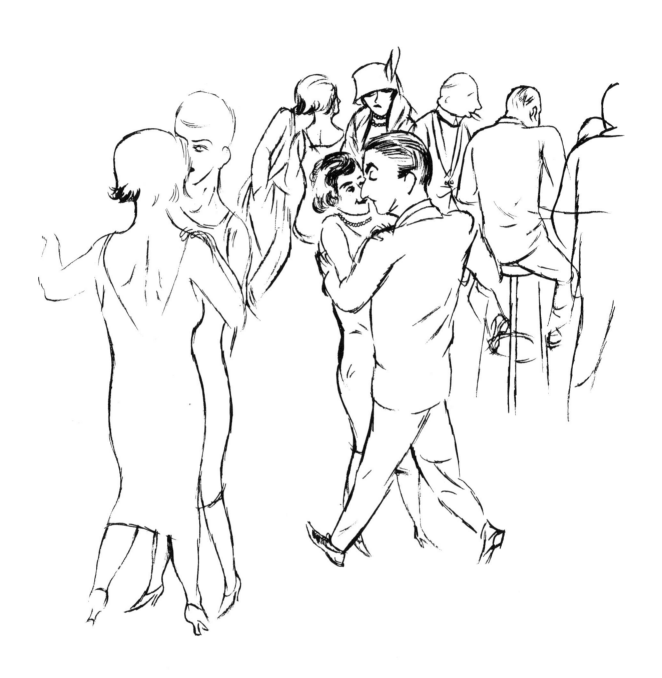

Total devotion from 5:00 to 7:00
Hingabe von 5–7

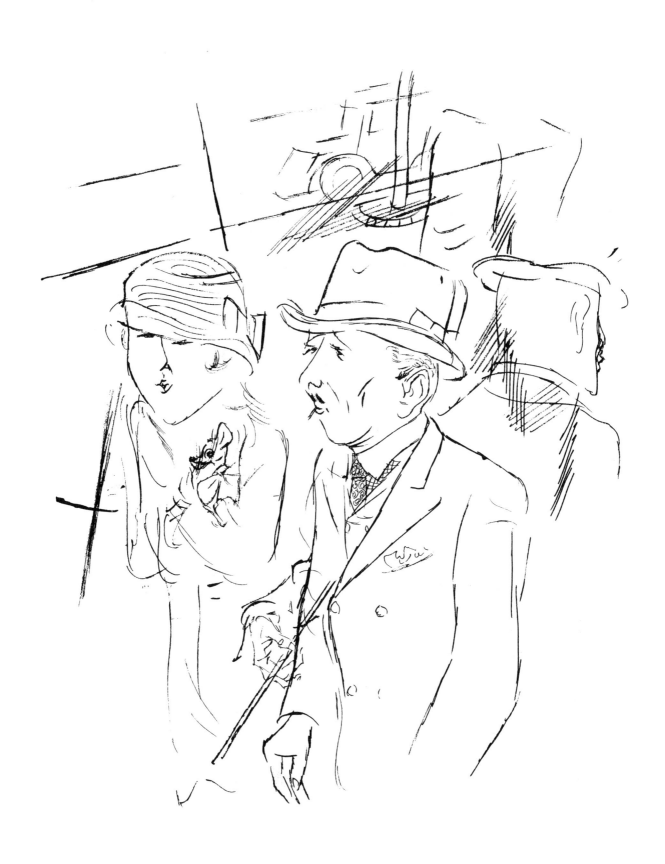

Where are we off to now?
wo gehen wir jetzt hin? . . .

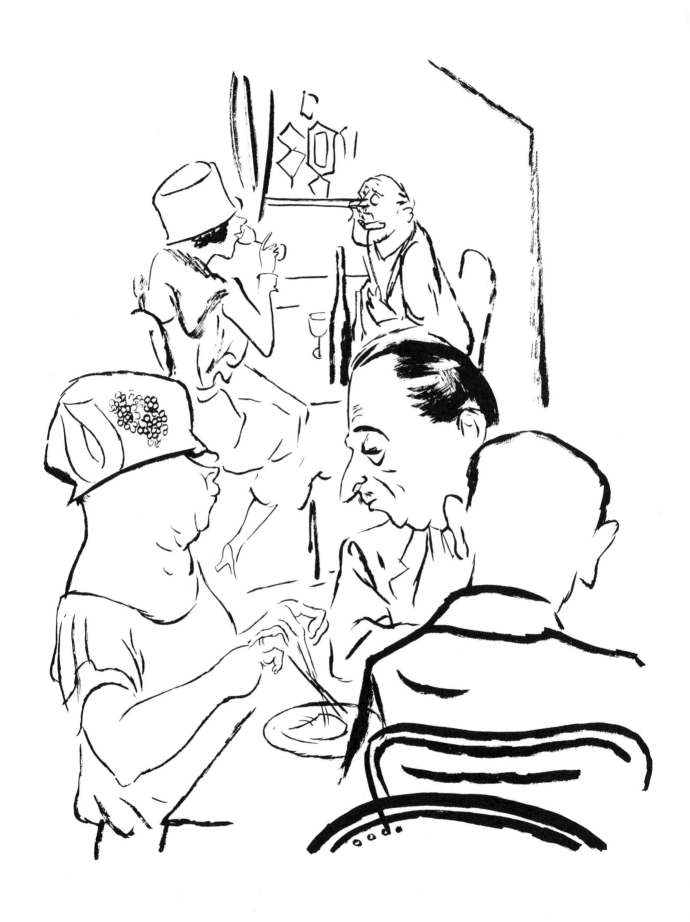

Lunch
Gabelfrühstück

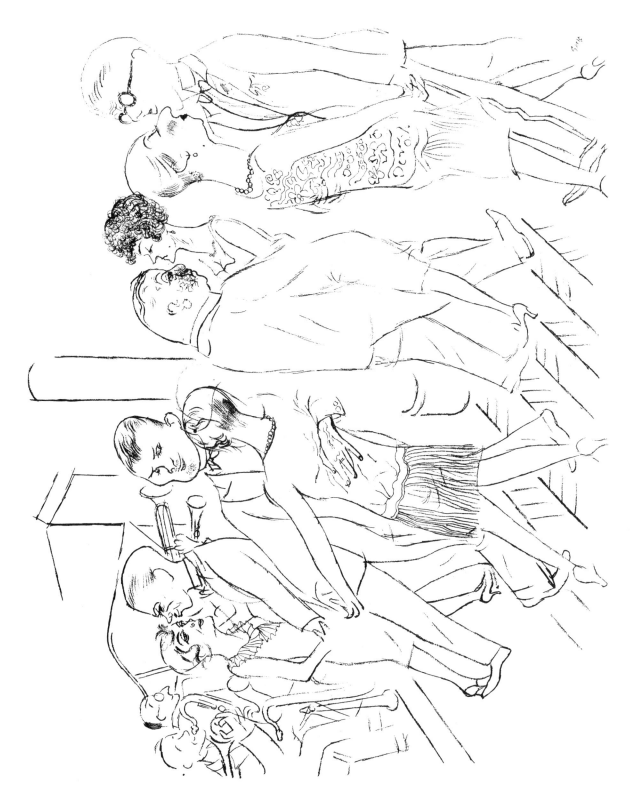

Pots and lids Töpfe und Deckel

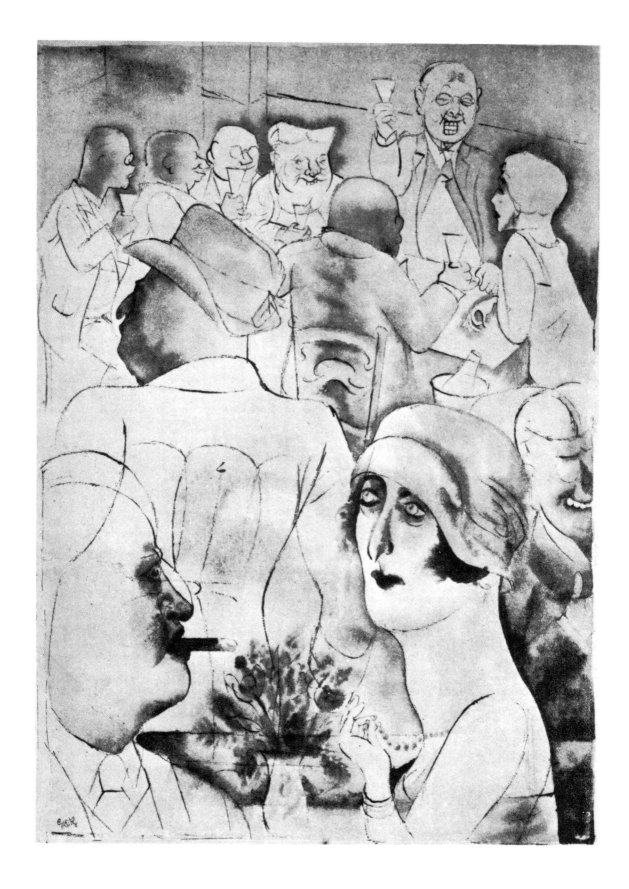

Let's drink to the ladies
ein Glas den Damen

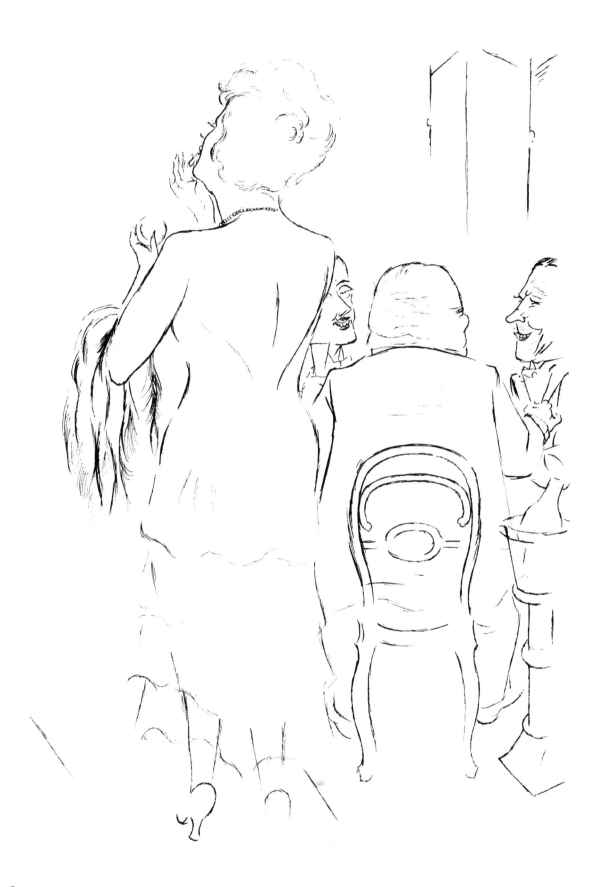

On an expense account
auf Spesenkonto

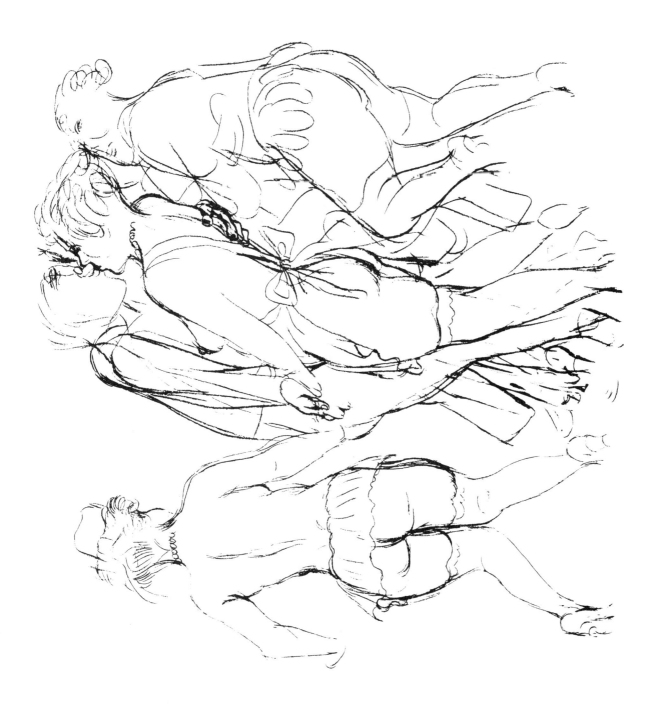

Crazy doings Strudel

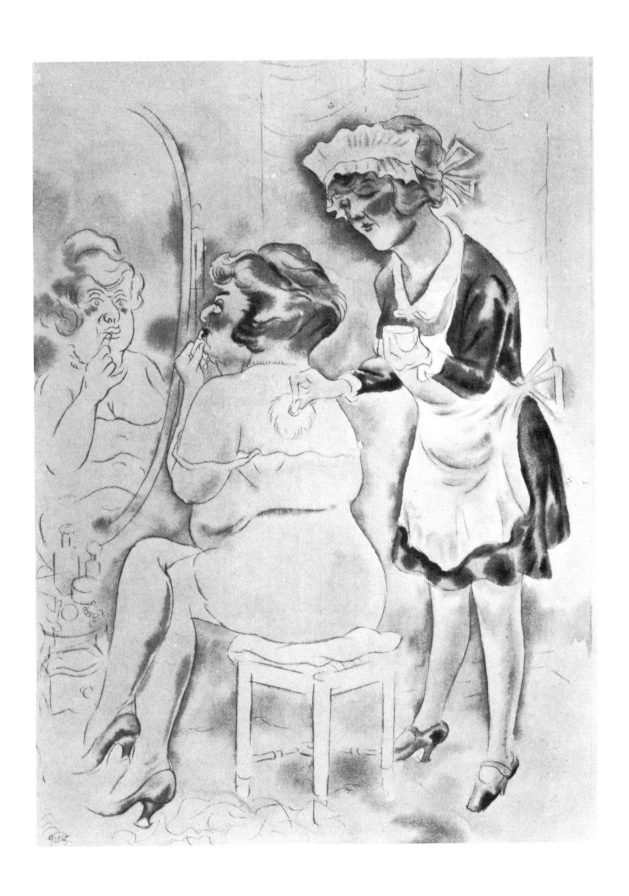

To the unknown god
dem unbekannten Gott

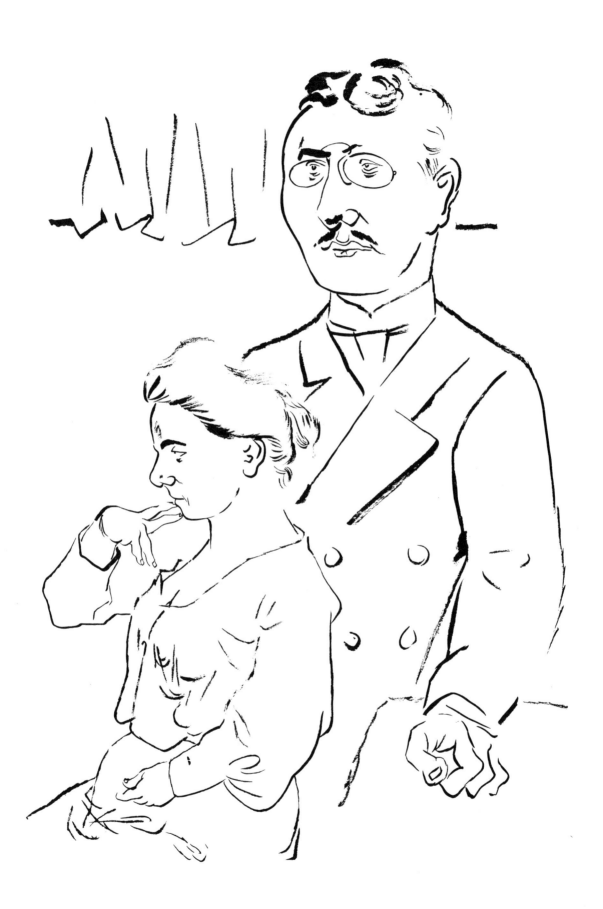

Faced with important decisions
vor wichtigen Entschlüssen

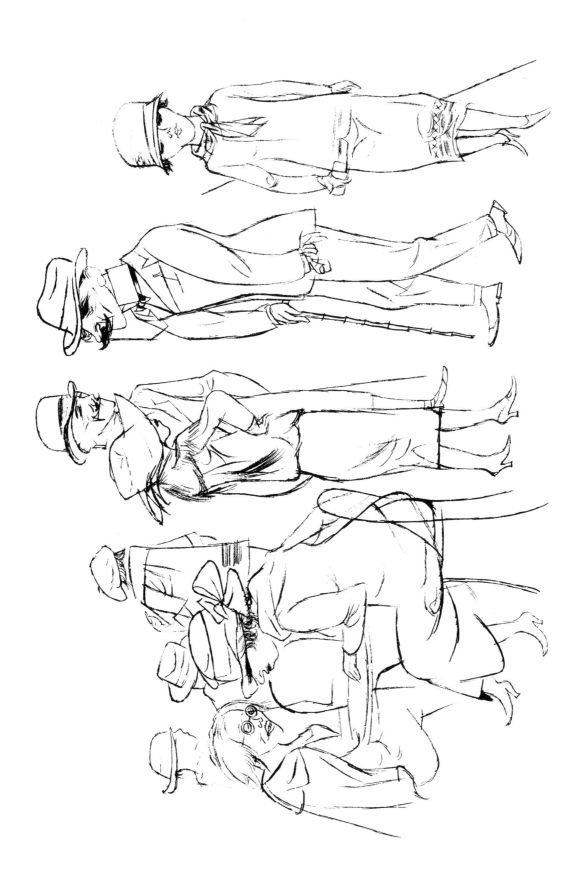

Unemployed ohne Beruf

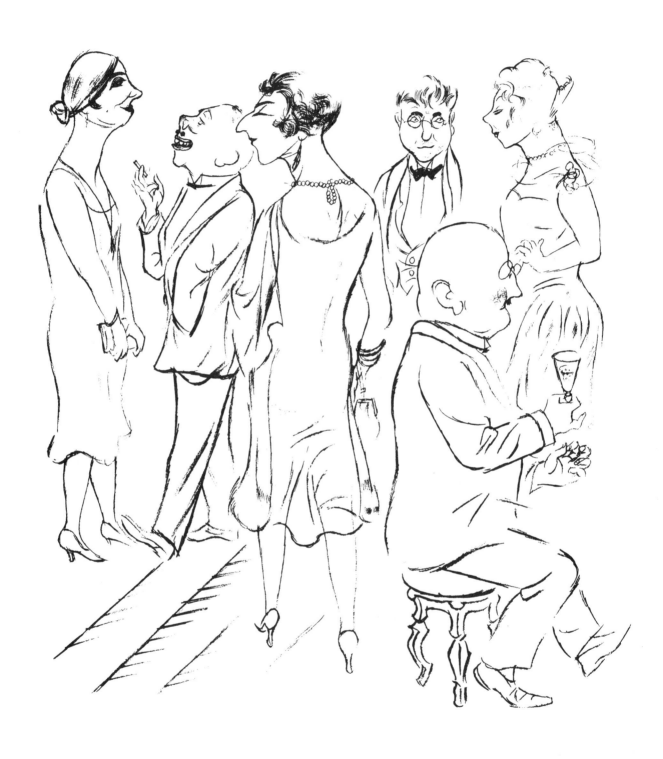

The same ones all the time
Immer dieselben

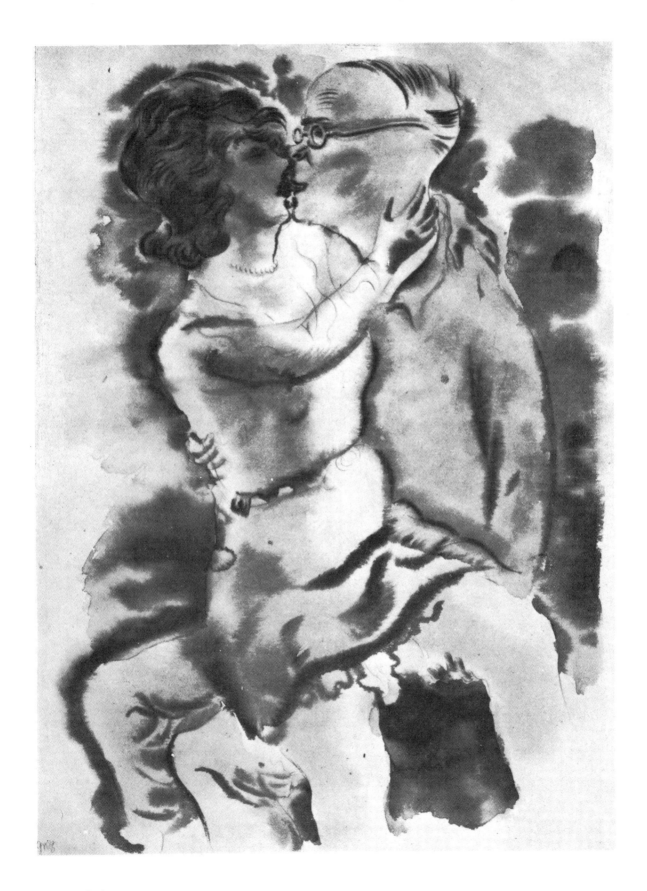

Like turtledoves
wie die Tauben

17

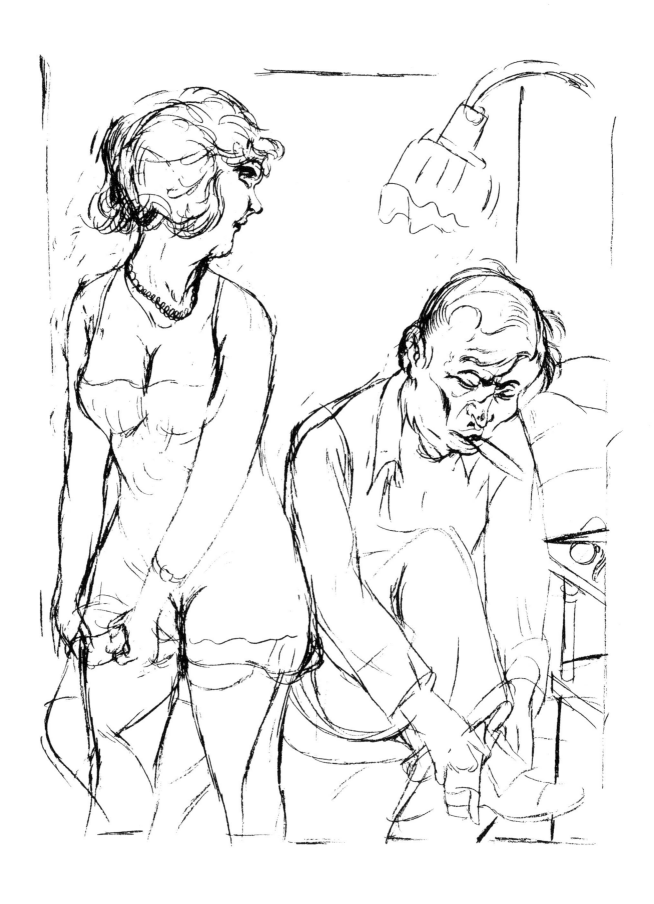

It's sad
. . . triste est!

[Probably an allusion to the quotation ''Omne animal post coitum triste''
which also appears in a Hogarth engraving of a similar scene.]

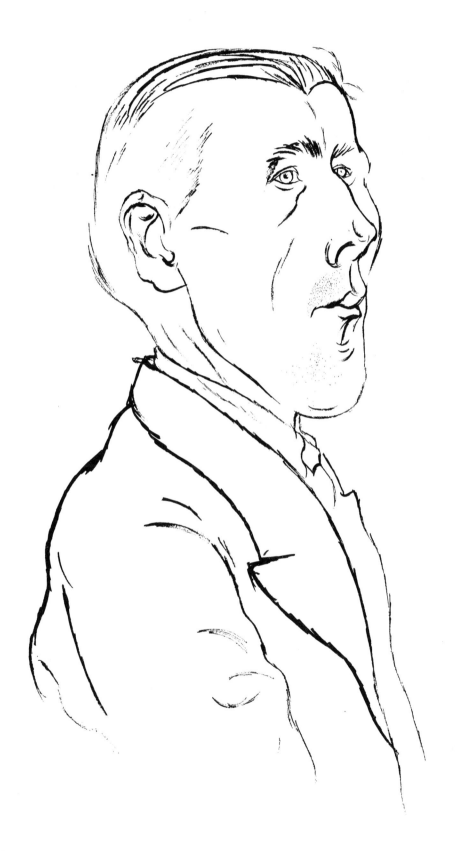

A love child
ein Kind der Liebe

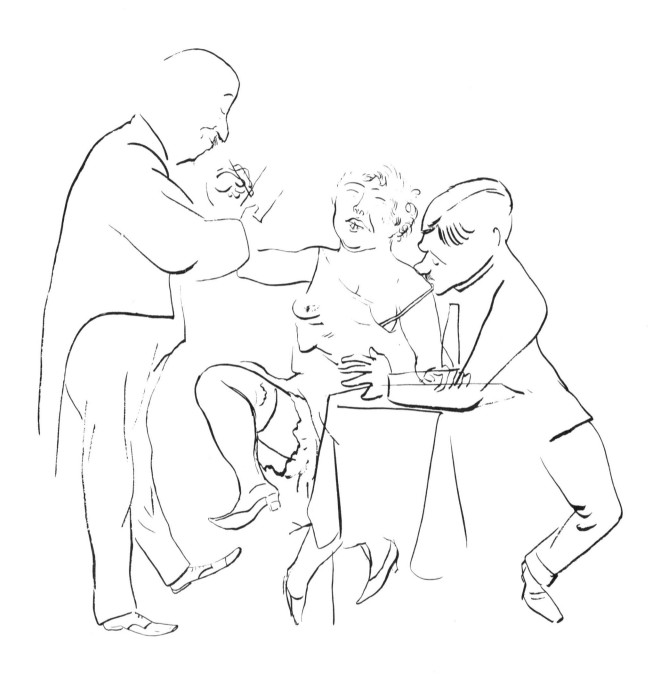

A man in the know
ein Wissender

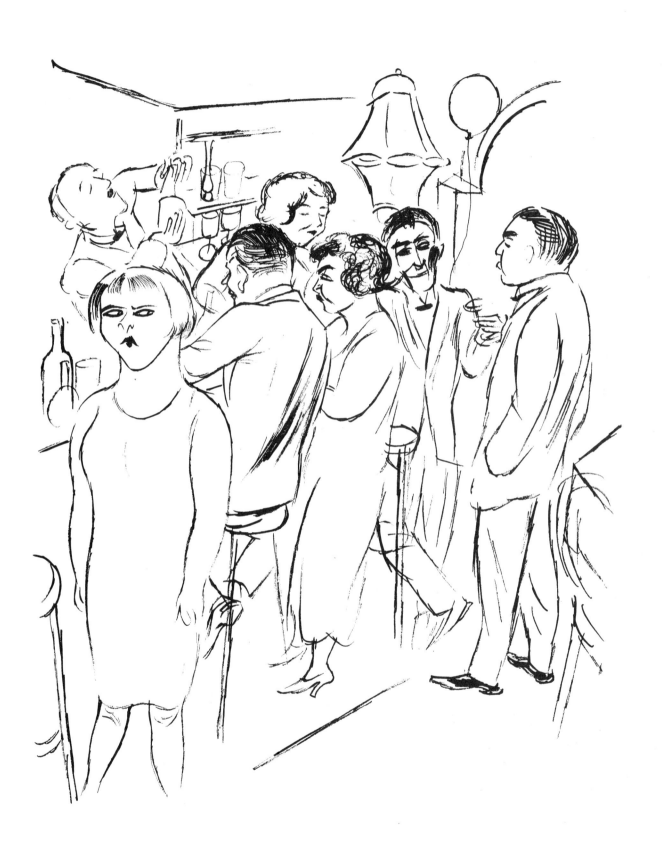

A Manhattan
ein Manhattan Coctail

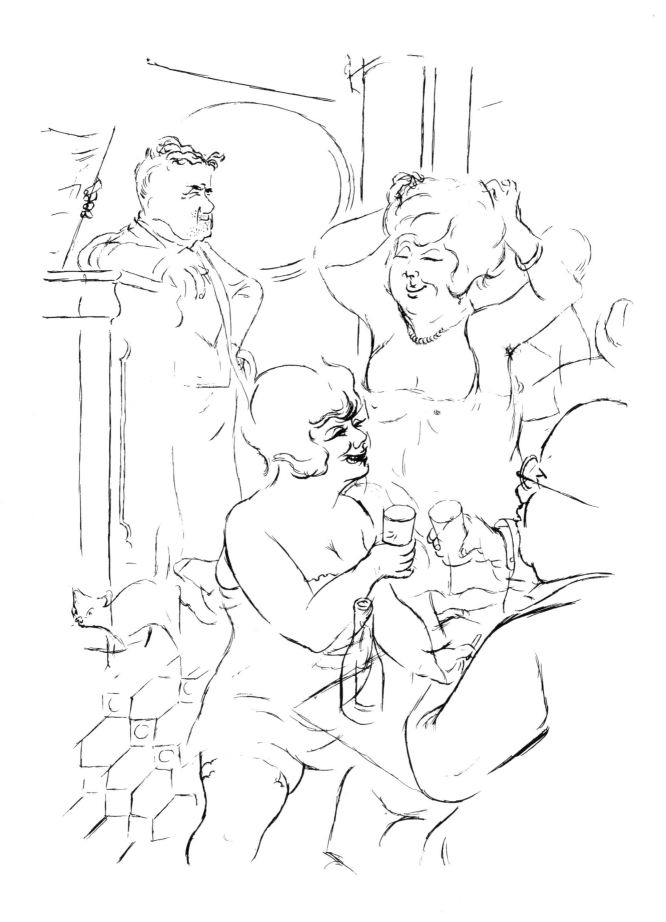

Transit trade
Durchgangsverkehr

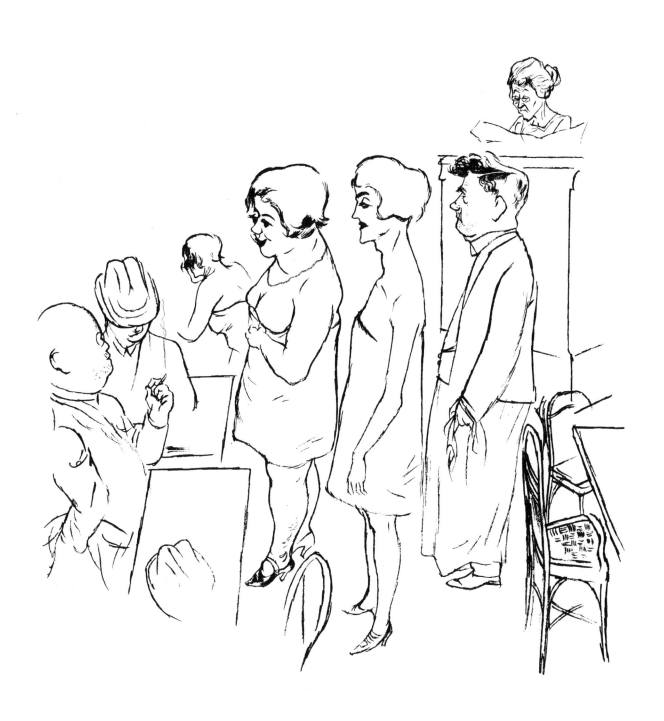

Supply and demand
Angebot und Nachfrage

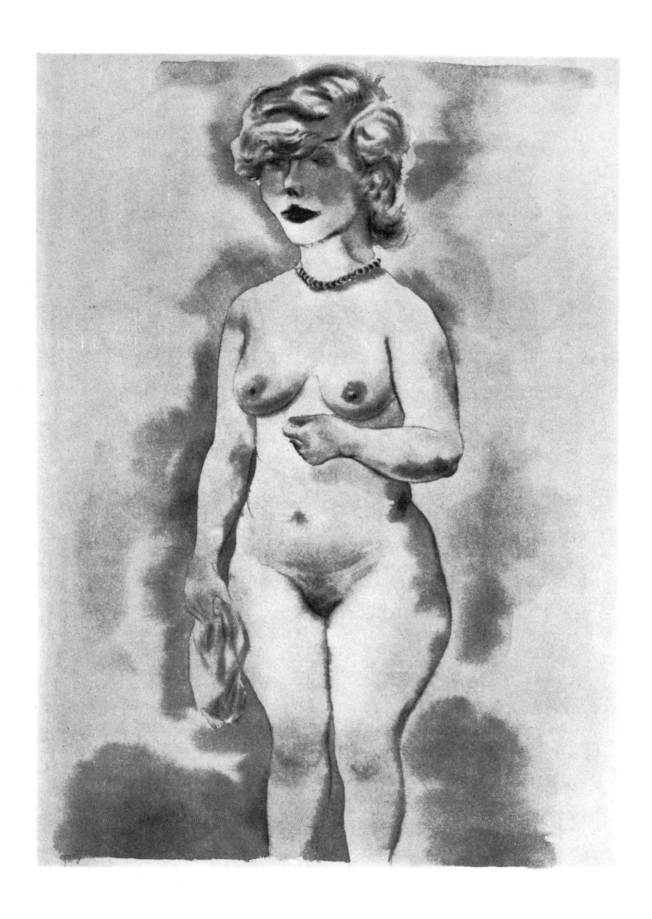

Raspberry
Himbeere

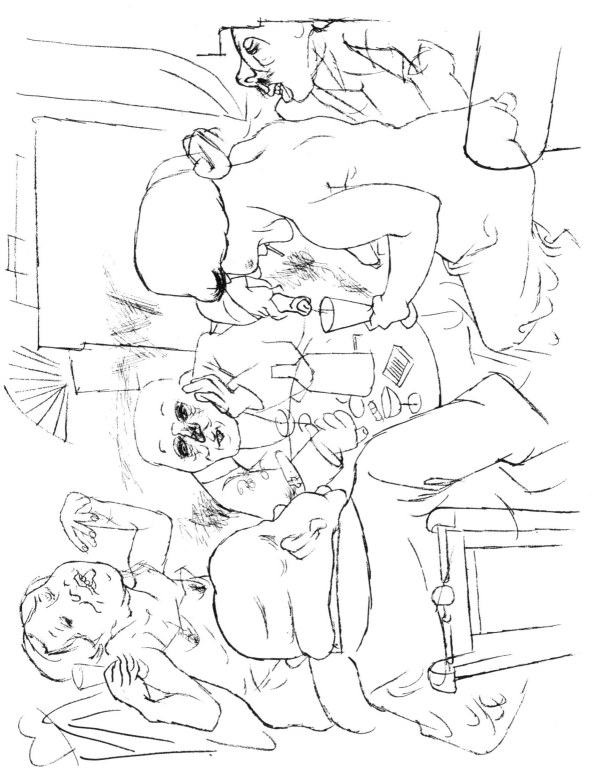

Savoir vivre

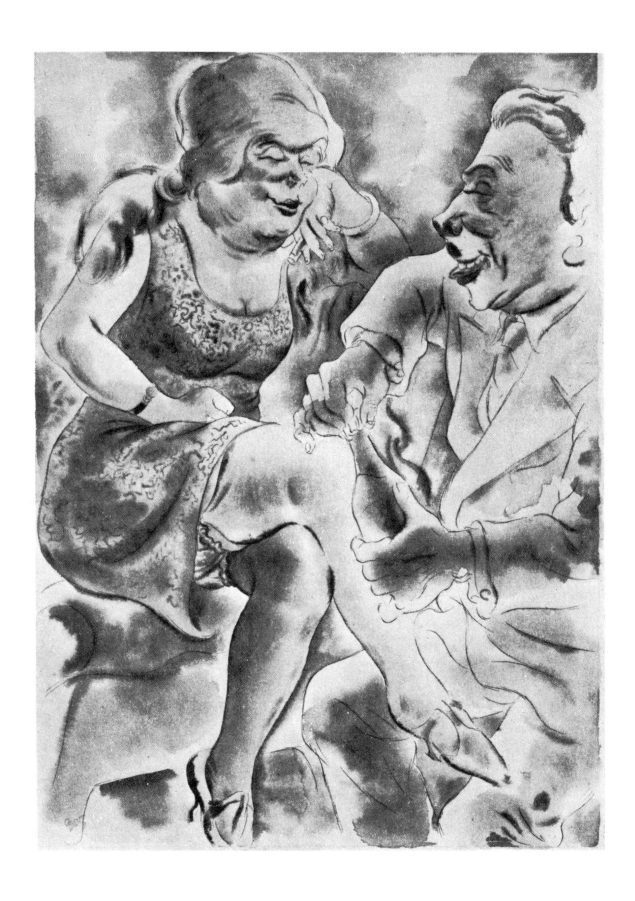

Last bottle
Letzte Flasche

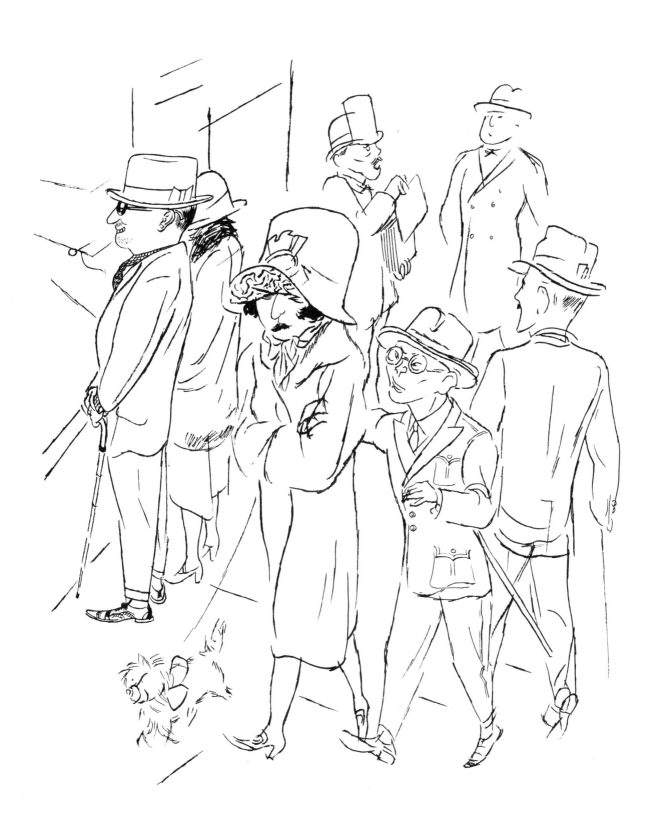

From hand to hand
von Hand zu Hand

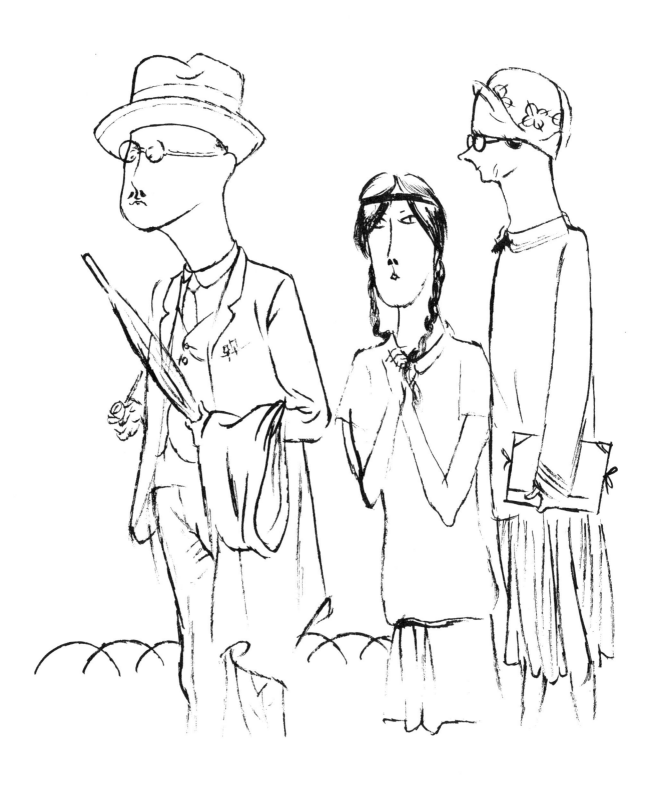

A blank page, or The inexperienced
unbeschriebenes Blatt

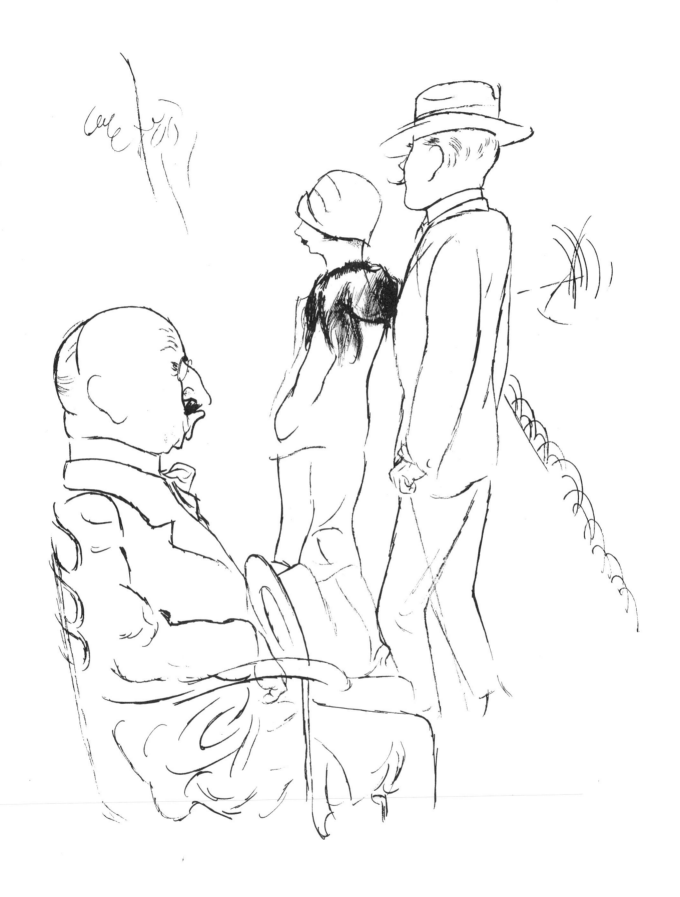

Inner voice
Innere Stimme

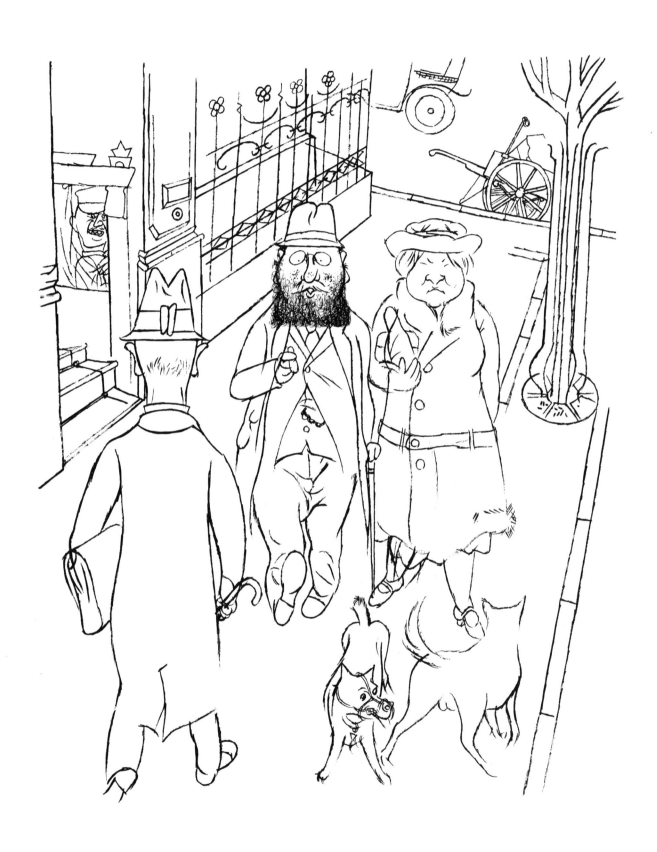

Staunch principles
feste Grundsätze

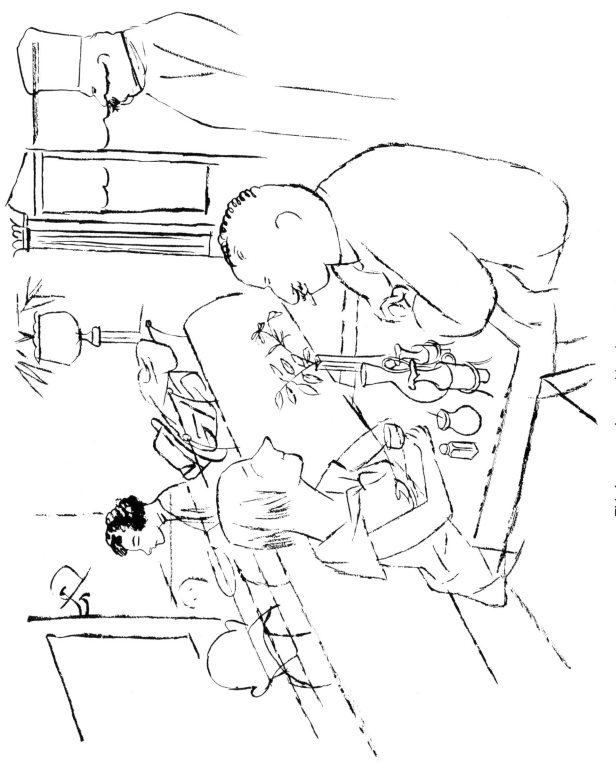

This is a cozy place hier sitzt man gut

31

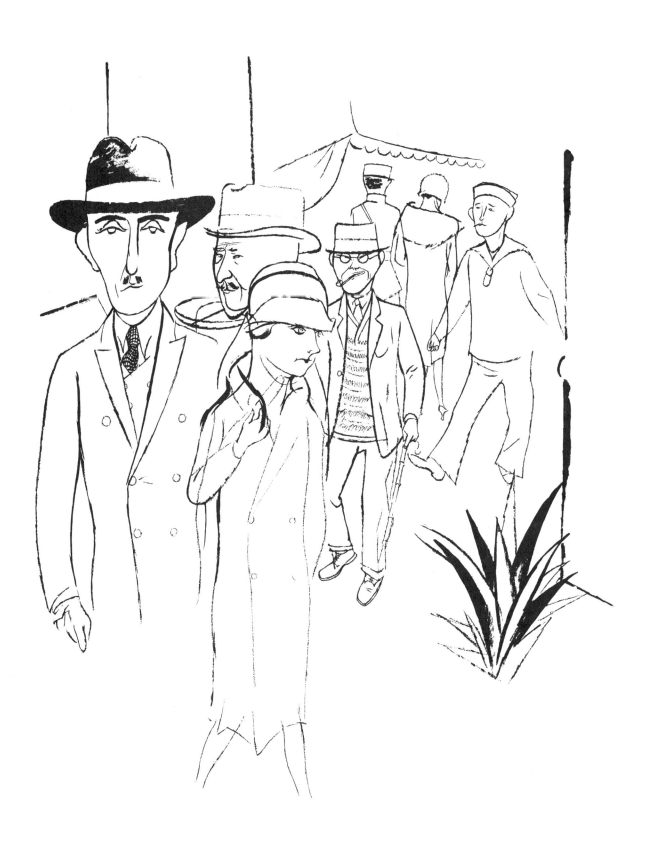

Driftwood
Treibholz

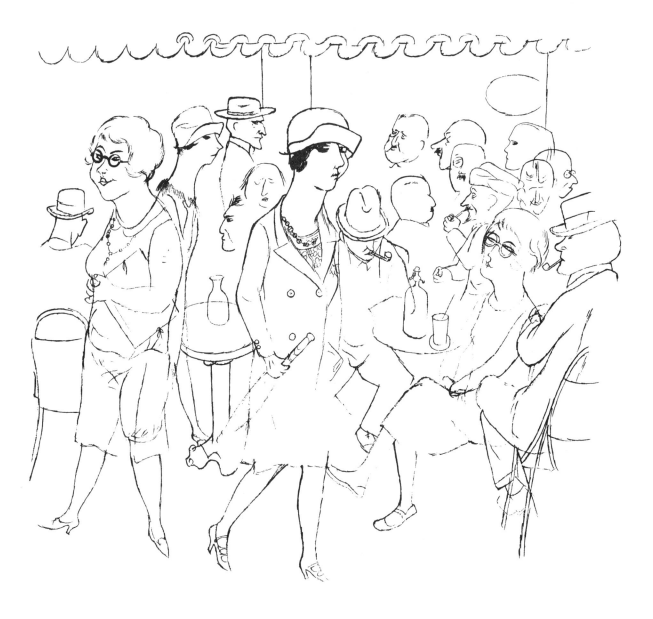

No prejudices
ohne Vorurteile

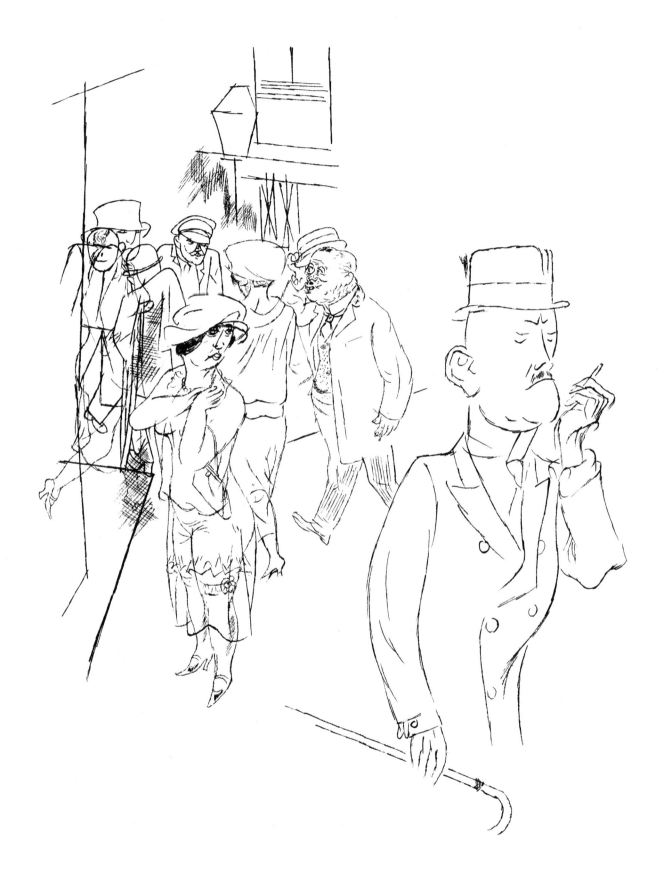

Not his type
nicht sein Geschmack

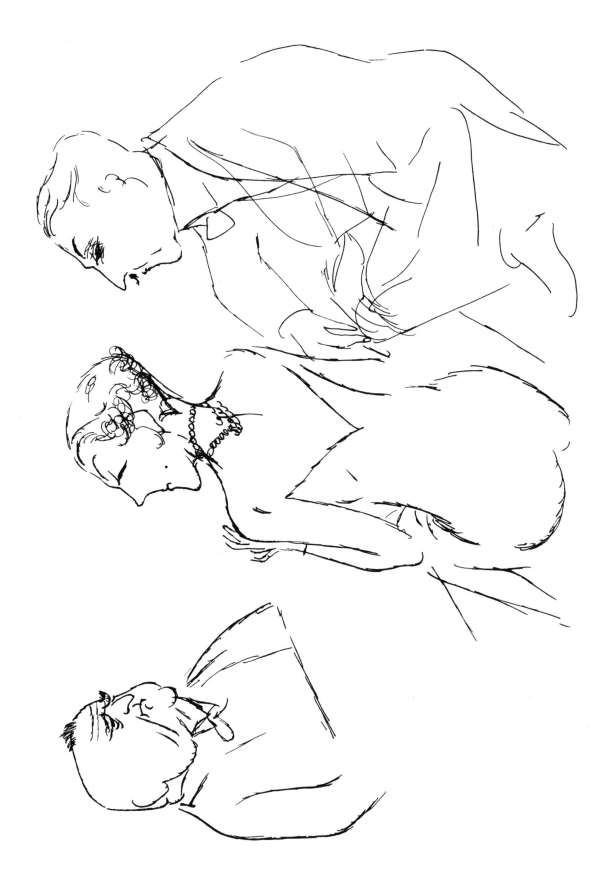

Making a good match gute Partie

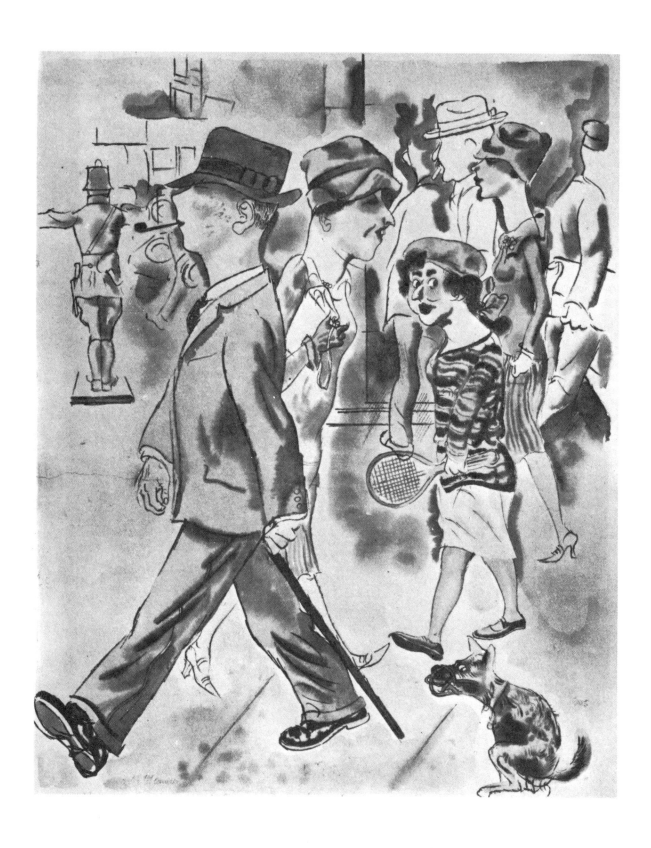

Dressed comme il faut
frisch in Schale

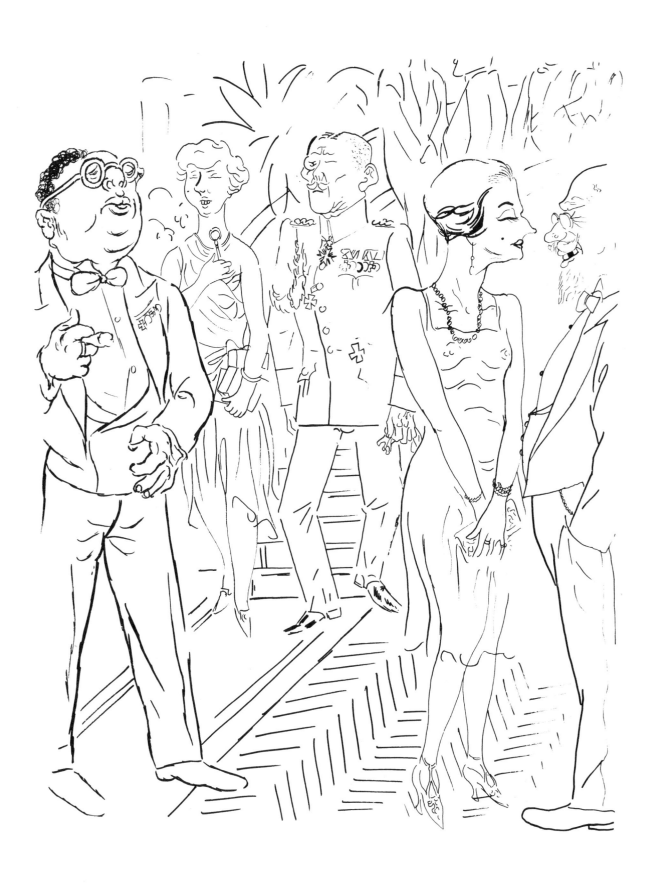

Success!
es ist erreicht

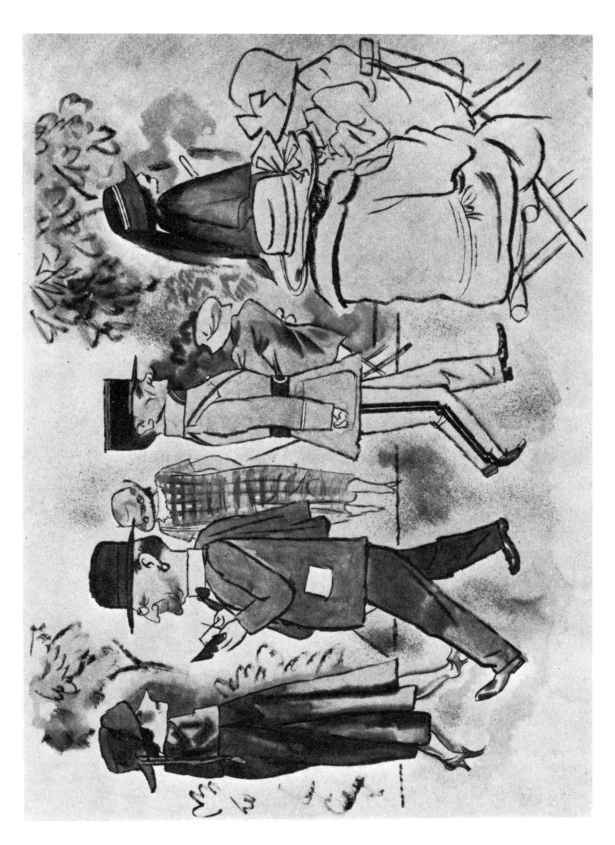

Single alleinstehend

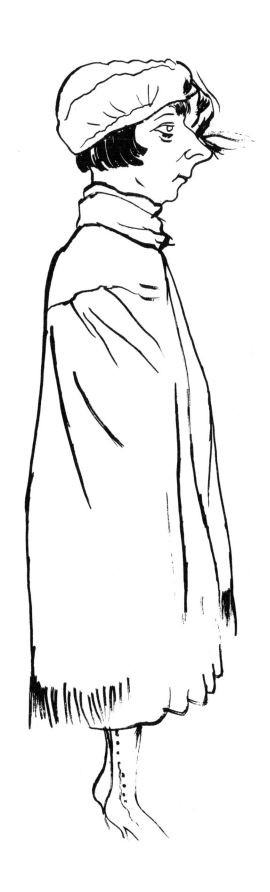

Drawn from life
Nach der Natur

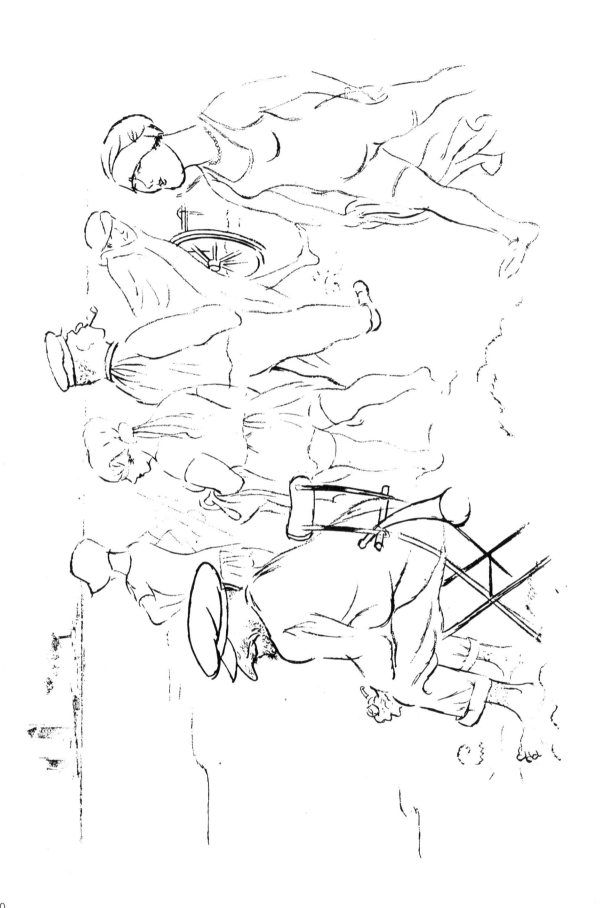

Grass widows Strohwitwen

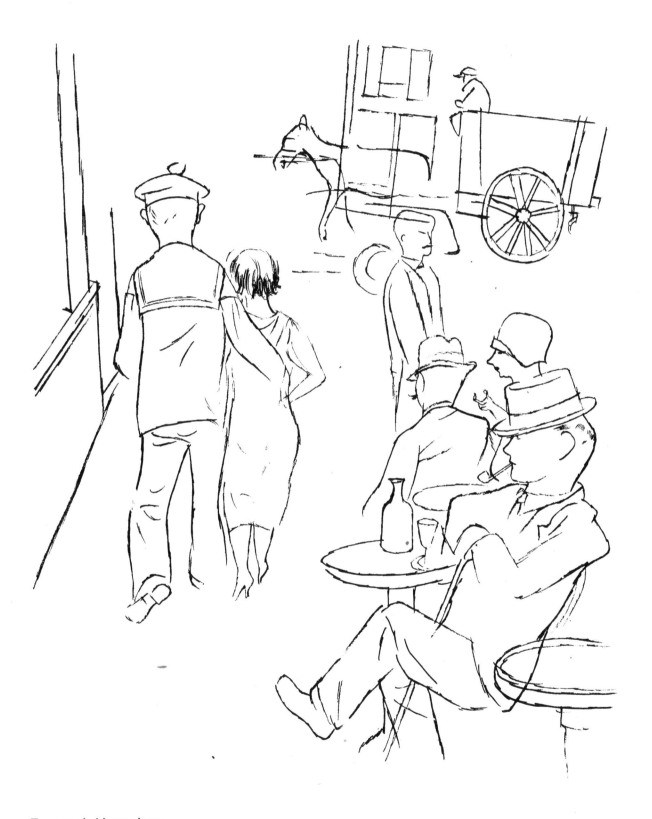

Two weeks' home leave
14 Tage Heimat

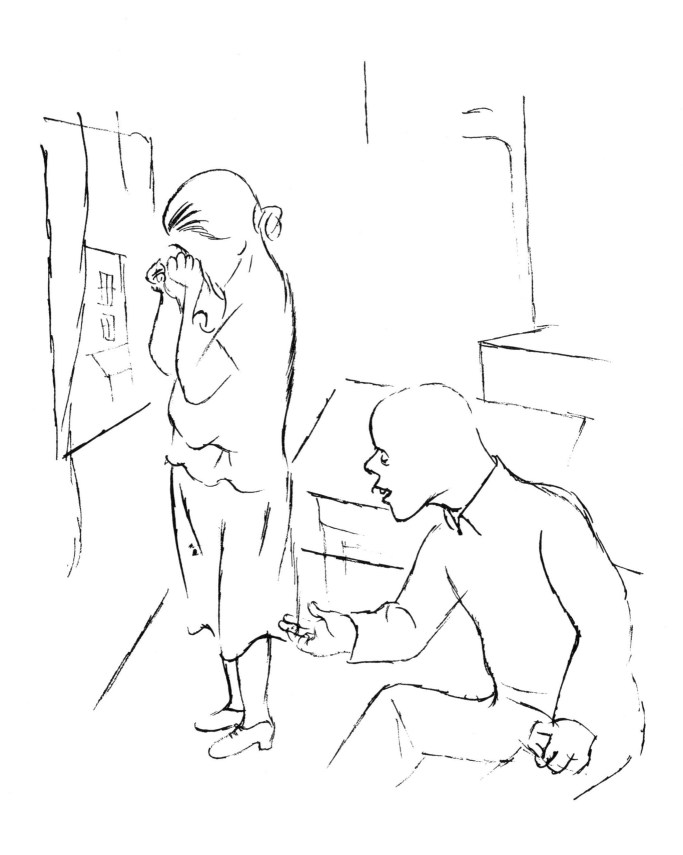

No results
ohne Resultat

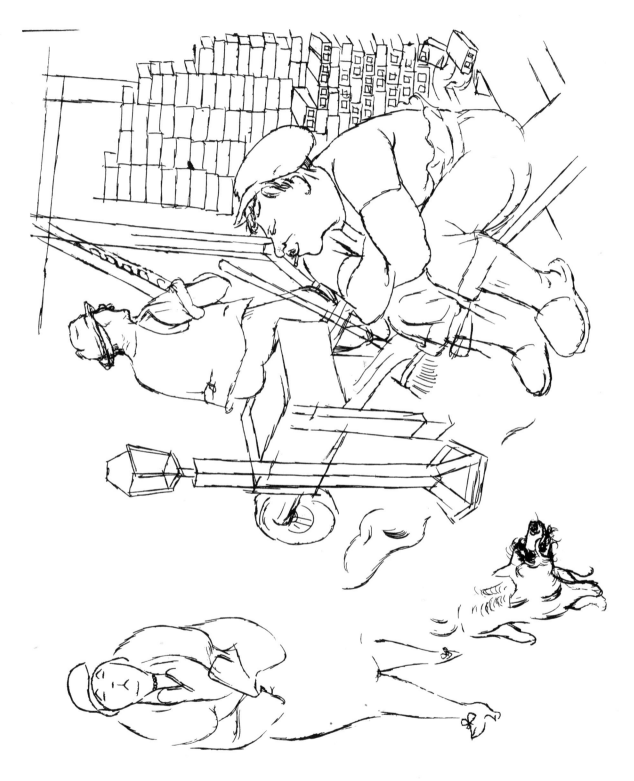

Snakeskin and clogs Schlangenhaut und Pantinen

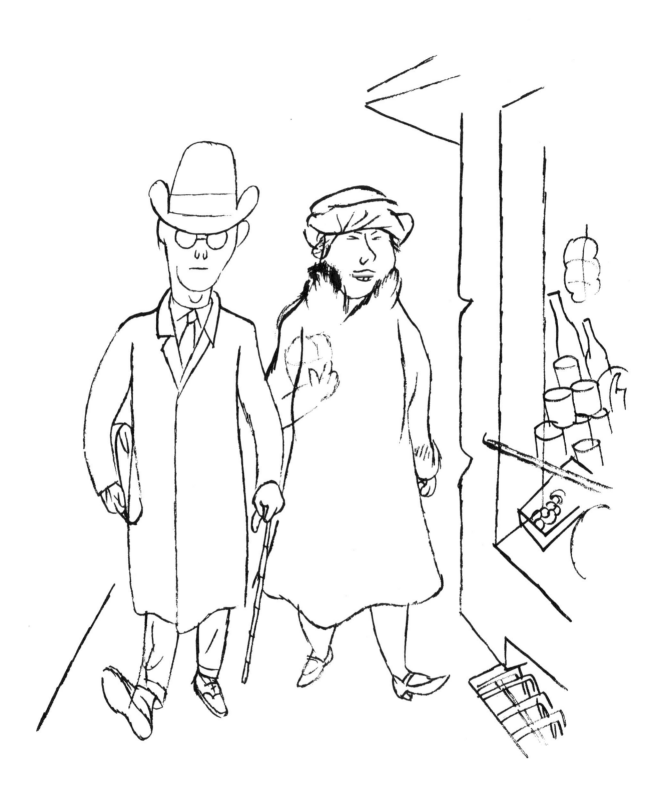

They belong together
Zusammengehörig

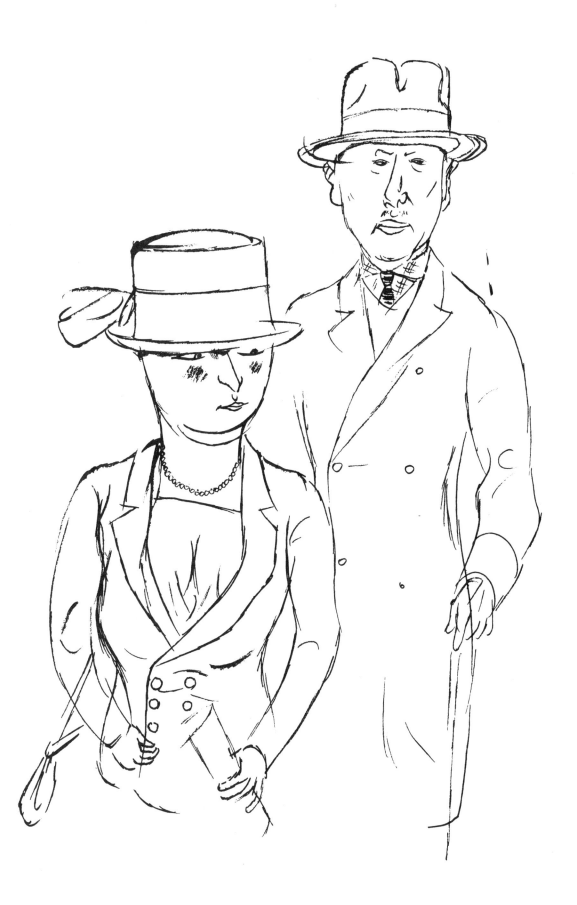

After a minor spat
Kleine Verstimmung

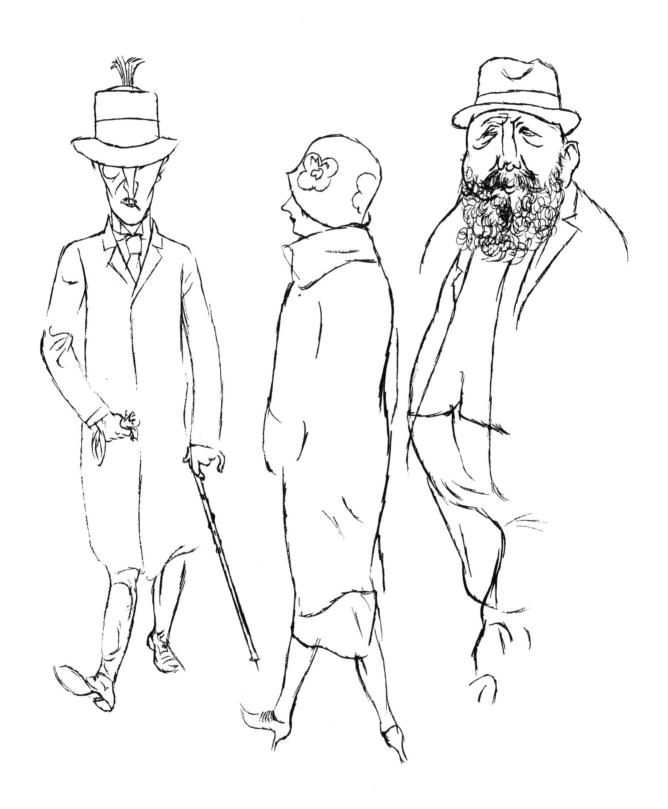

Triad
Dreiklang

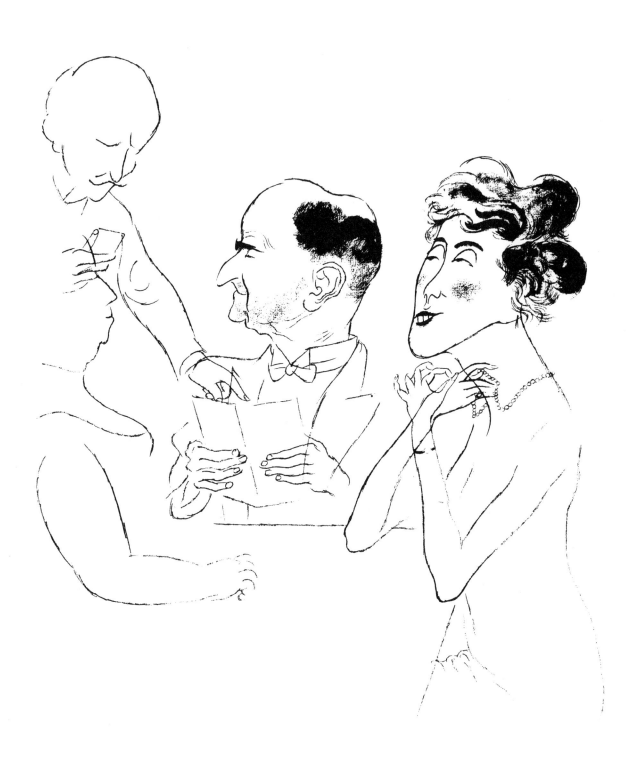

To each his own
Jedem das Seine

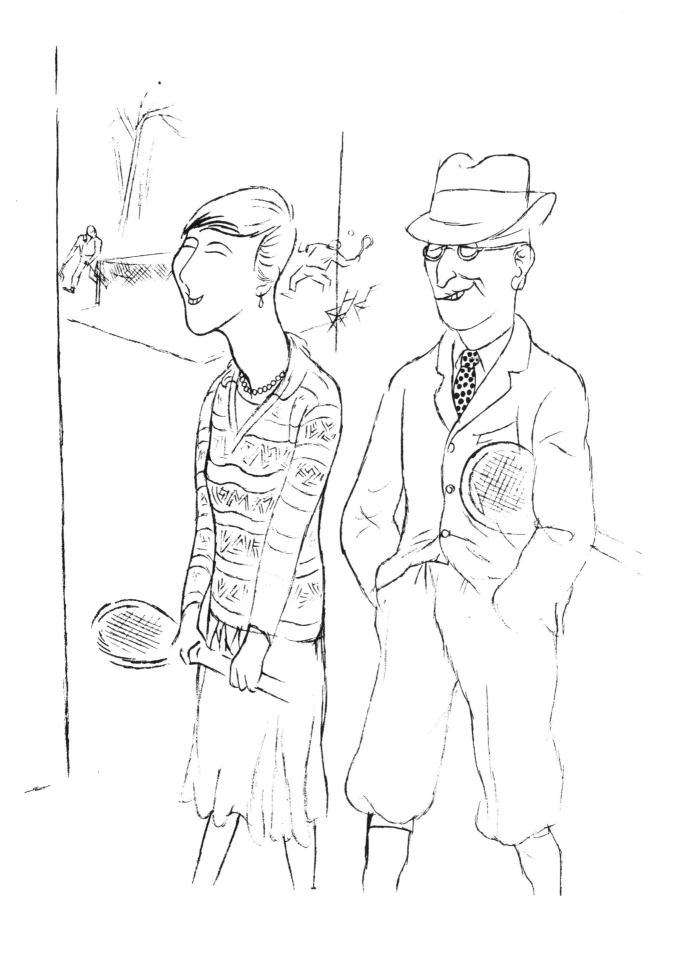

Well-directed balls
scharfe Bälle

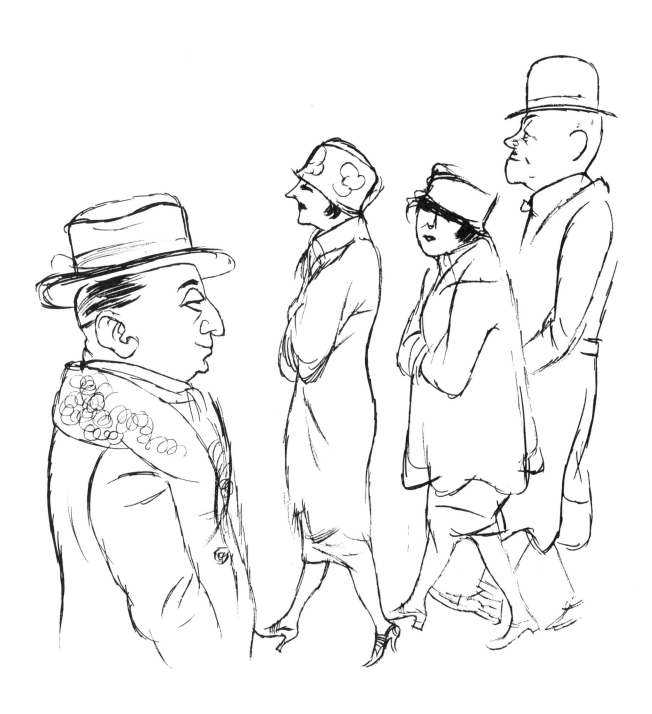

Birds of passage
Zugvögel

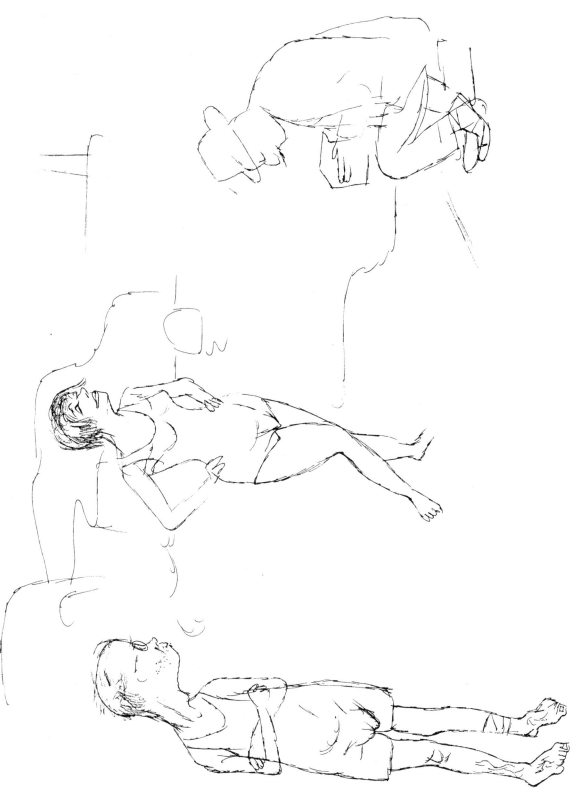

Vamp

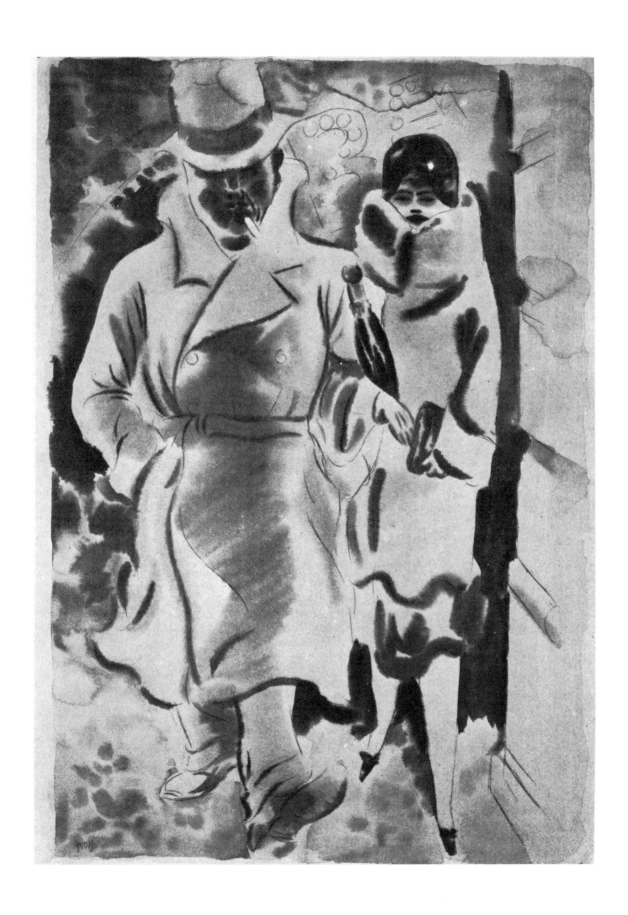

Sticking like a burr
Klette

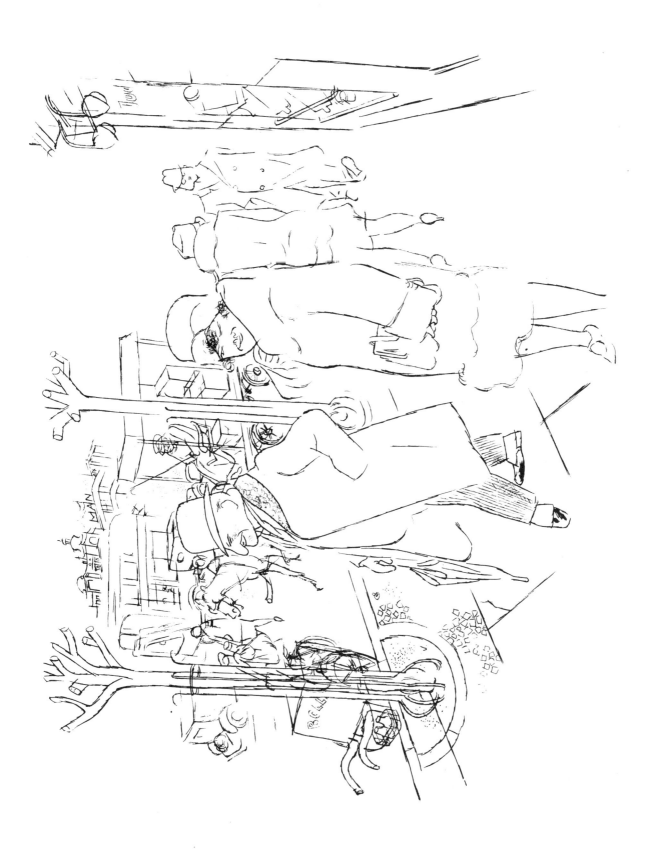

After business hours Nach Geschäftsschluss

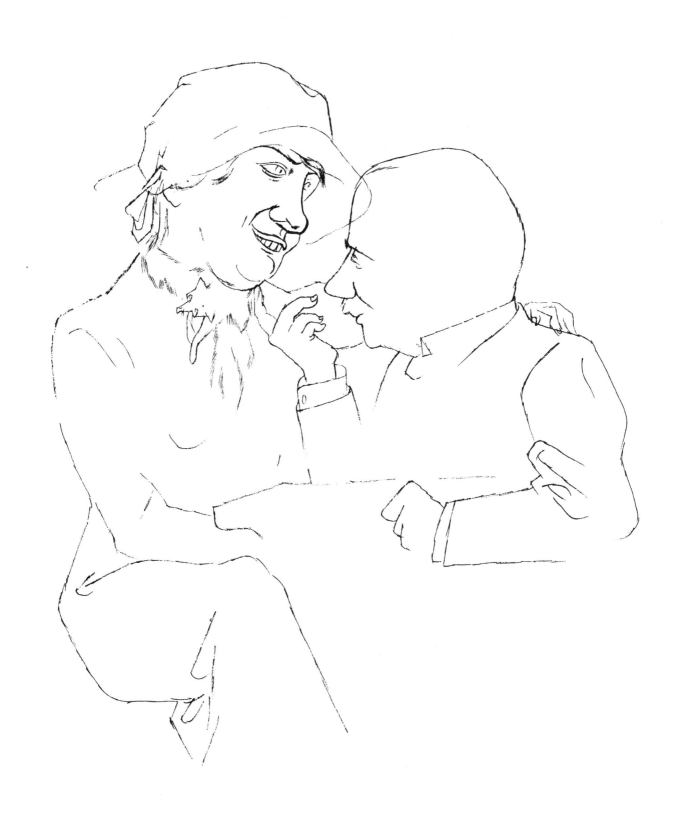

Do you like me just a little bit?
Hast du mich ein wenig gern?

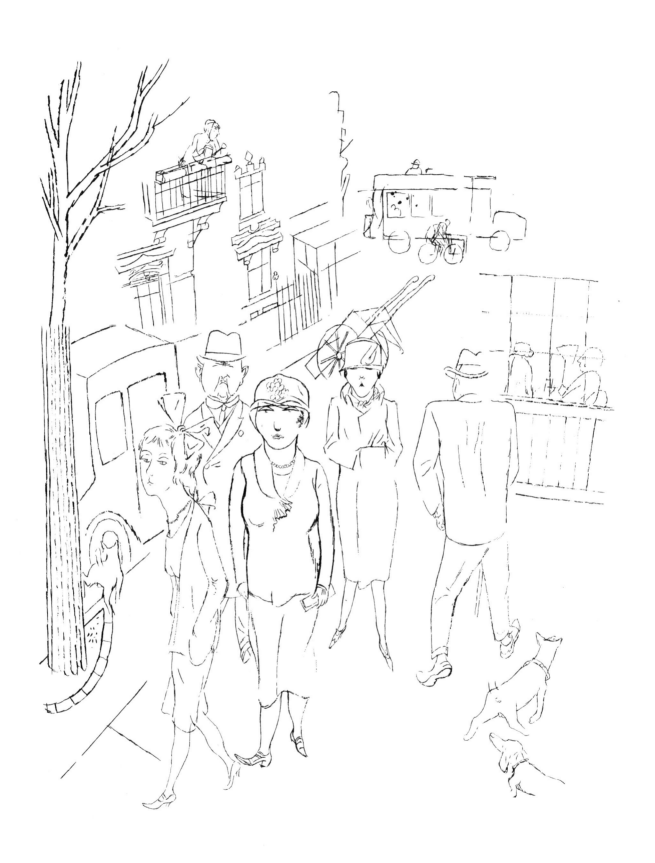

Unconnected
Zusammenhanglos

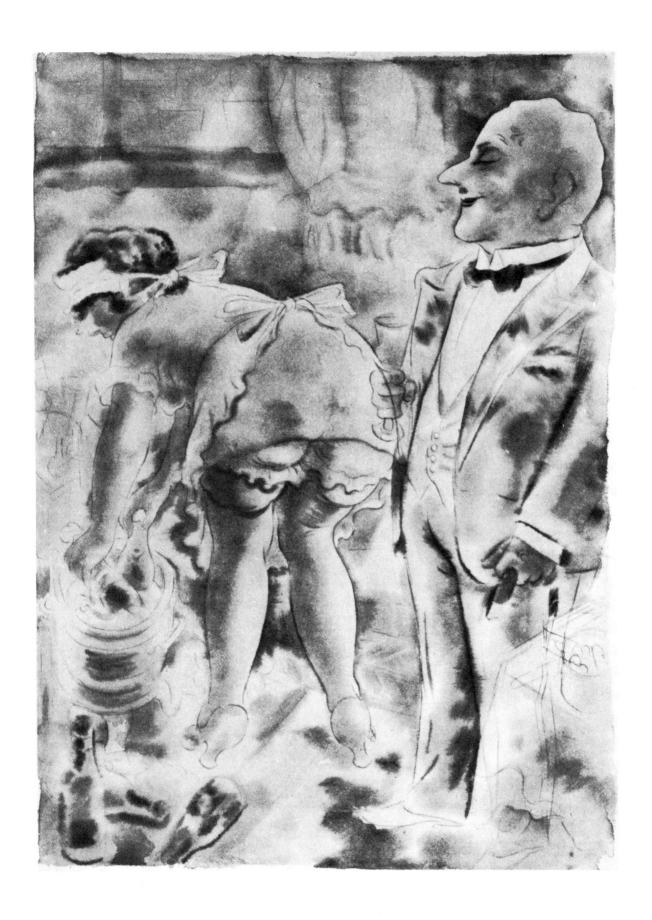

After the meal
nach Tisch

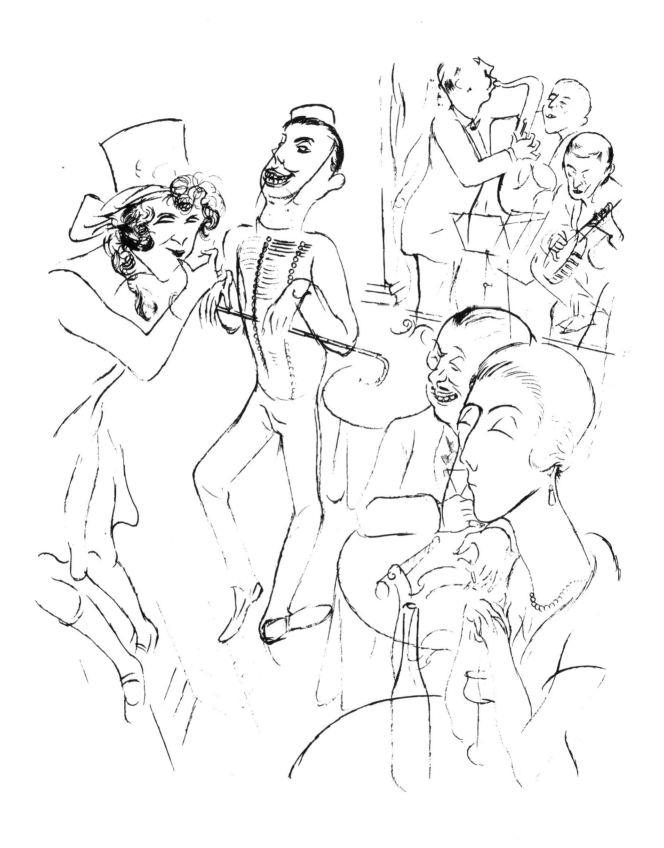

Having a good time
man lässt sich amüsieren

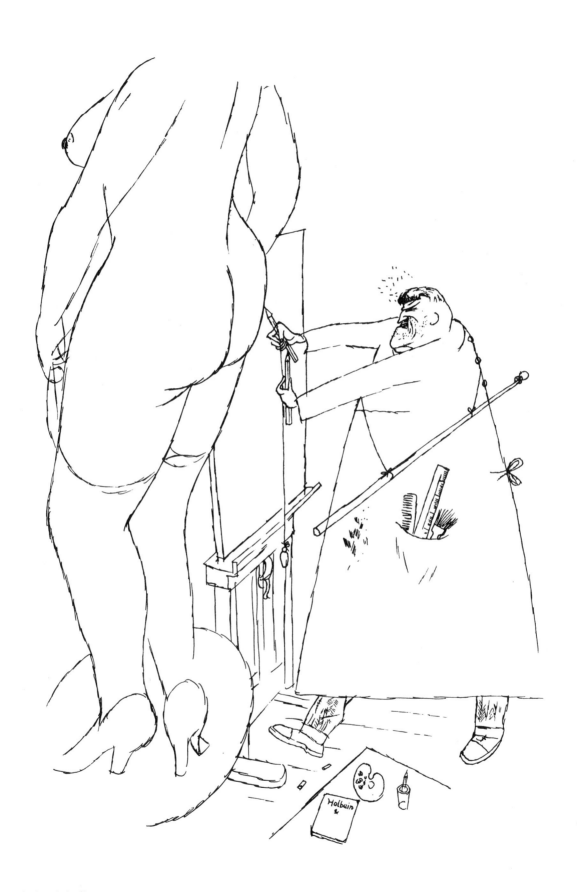

"New Objectivity"
neue Sachlichkeit

[Name of an art movement of the late Twenties reacting against Expressionism.]

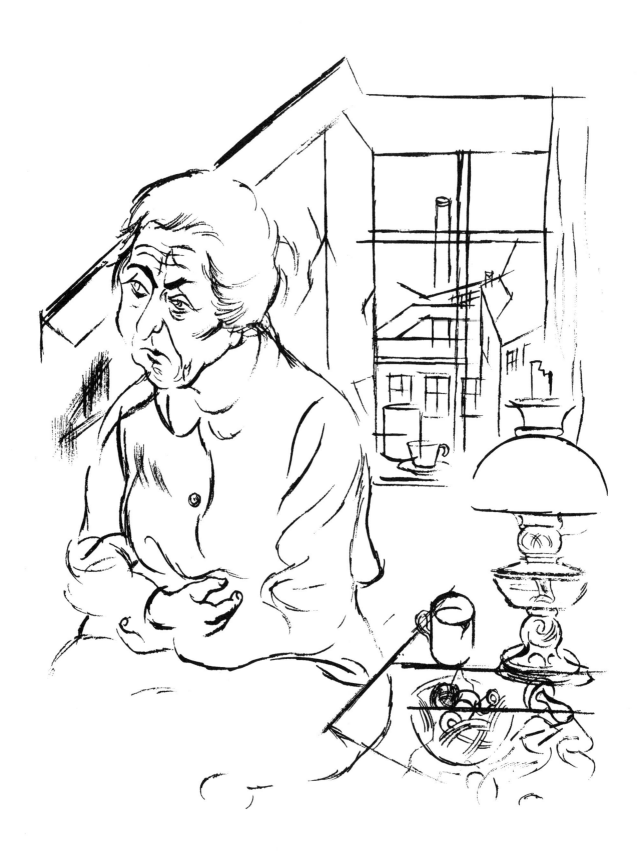

Once upon a time
es war einmal

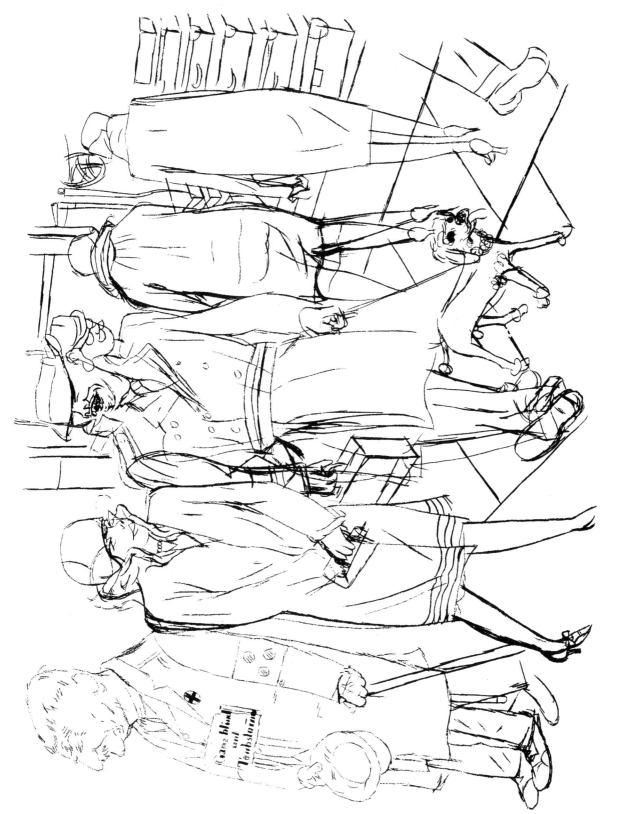

Those who live on love Die von der Liebe leben

[The old man's sign reads: "Completely blind and deaf-and-dumb."]

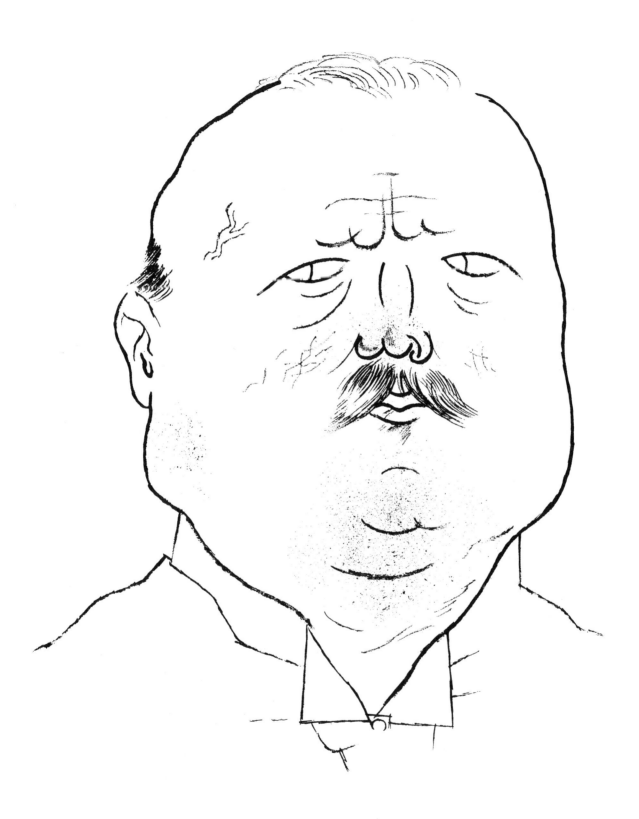

Man of honor
Ehrenmann

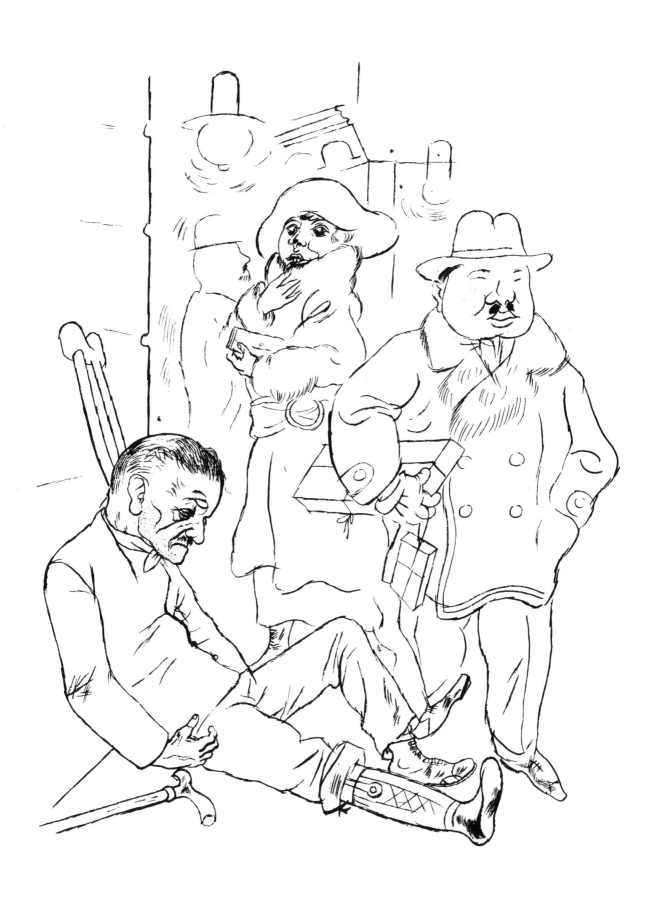

Careful, don't trip
Vorsicht, nicht stolpern

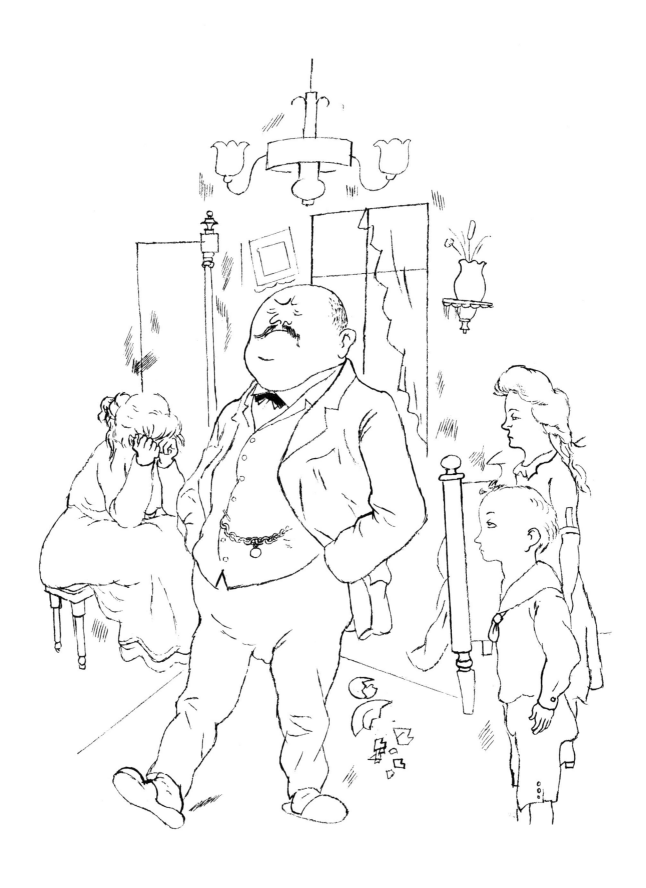

The family is the foundation of the state
die Familie ist die Grundlage des Staates

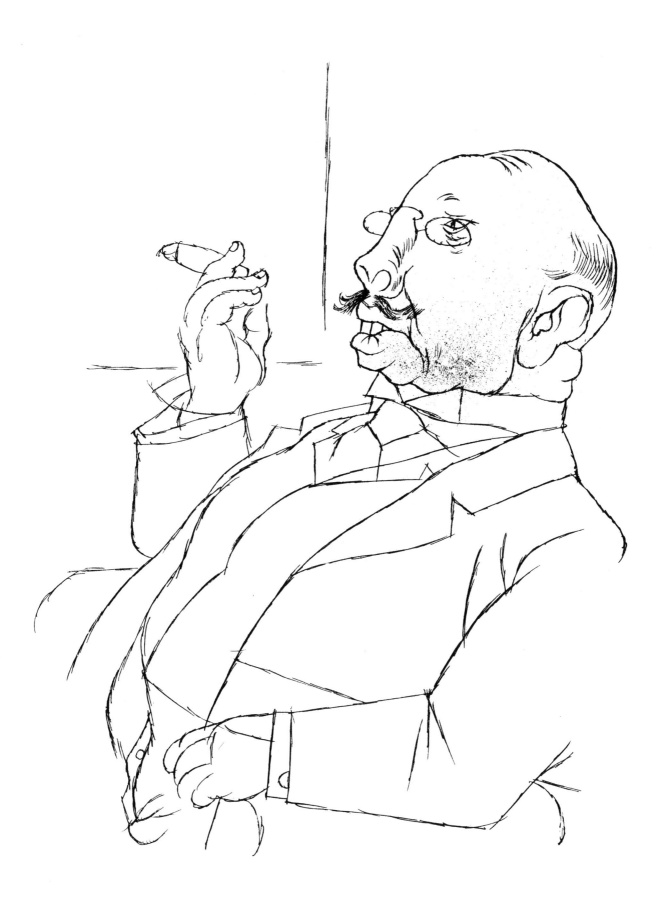

Man of the house
Hausherr

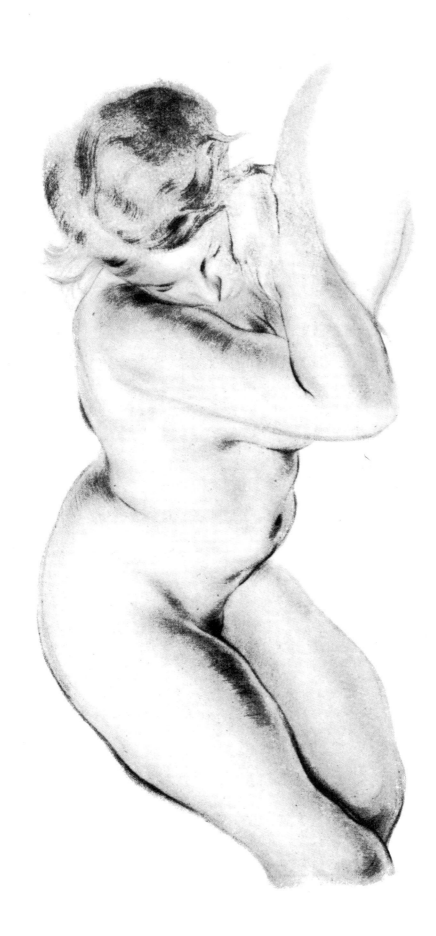

Dream
Traum

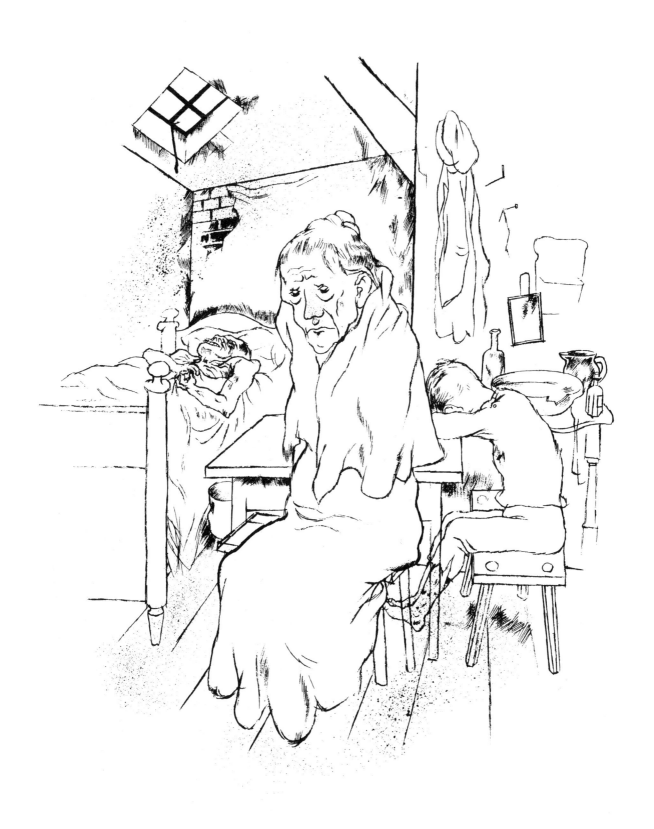

"Poverty is a great glow from within": Rilke
"Armut ist ein grosser Glanz von innen" (Rilke)

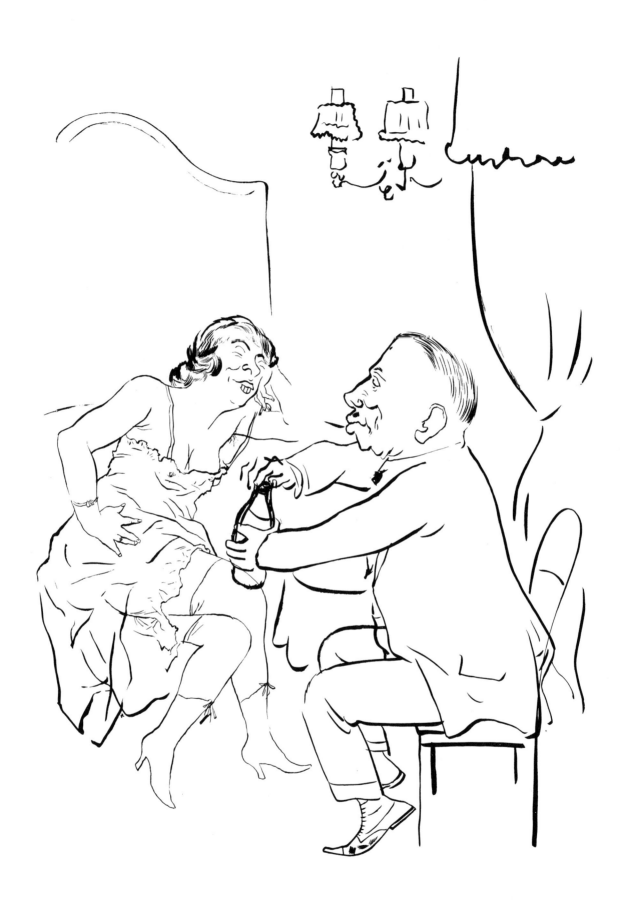

Two people, I
Zwei Menschen I

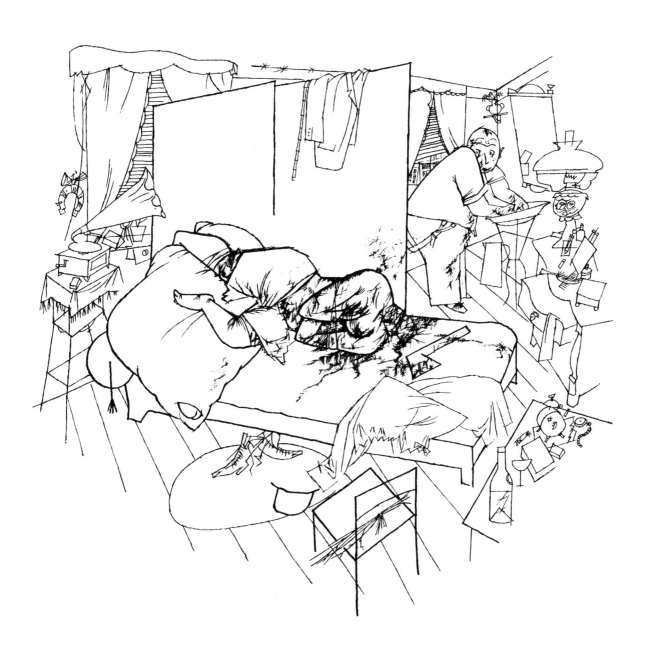

Two people, II
Zwei Menschen II

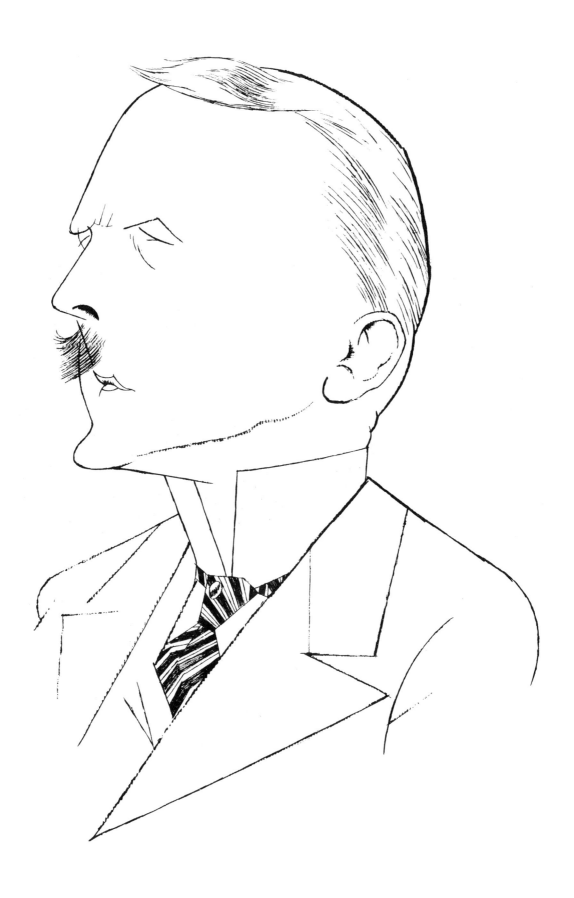

There's a smell of rabble here
's riecht hier nach Pöbel

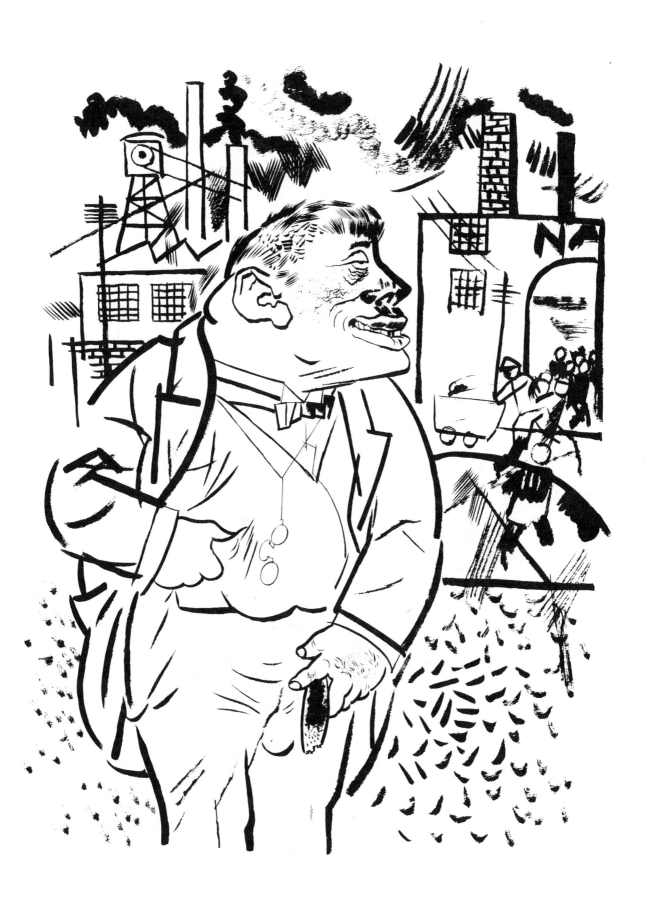

On his own power
Aus eigener Kraft

Ants, I Ameisen I

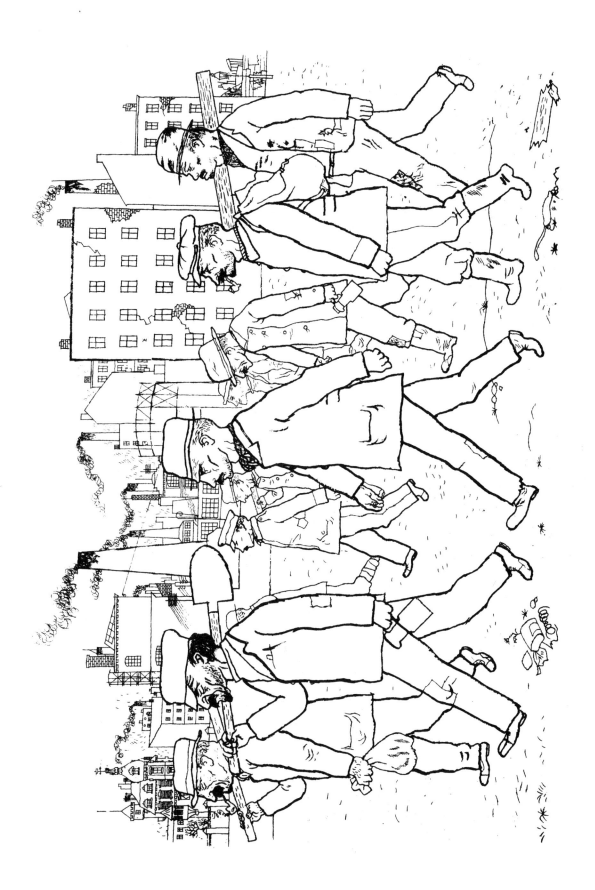

Ants, II Ameisen II

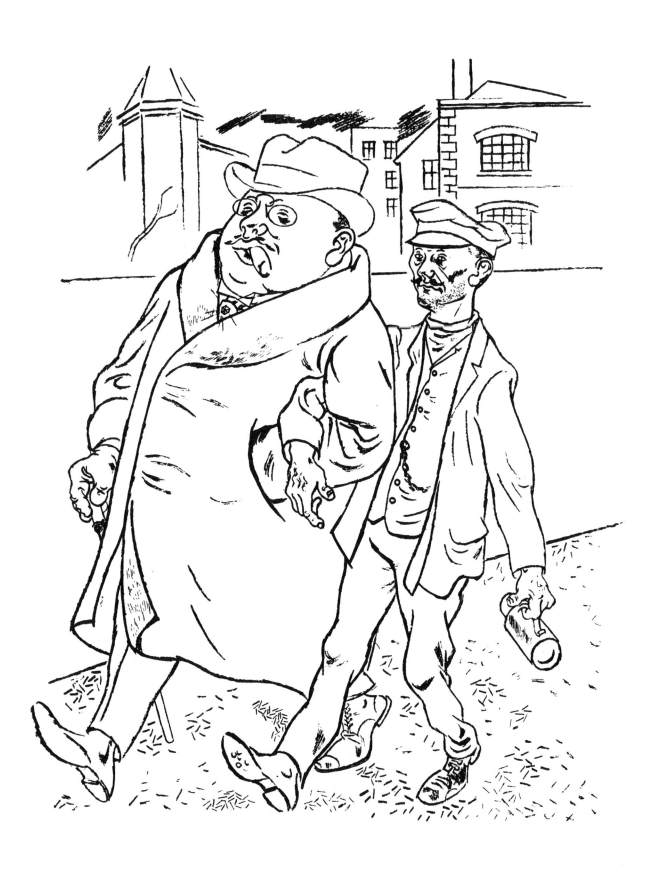

Peace between capital and labor
Friede zwischen Kapital und Arbeit

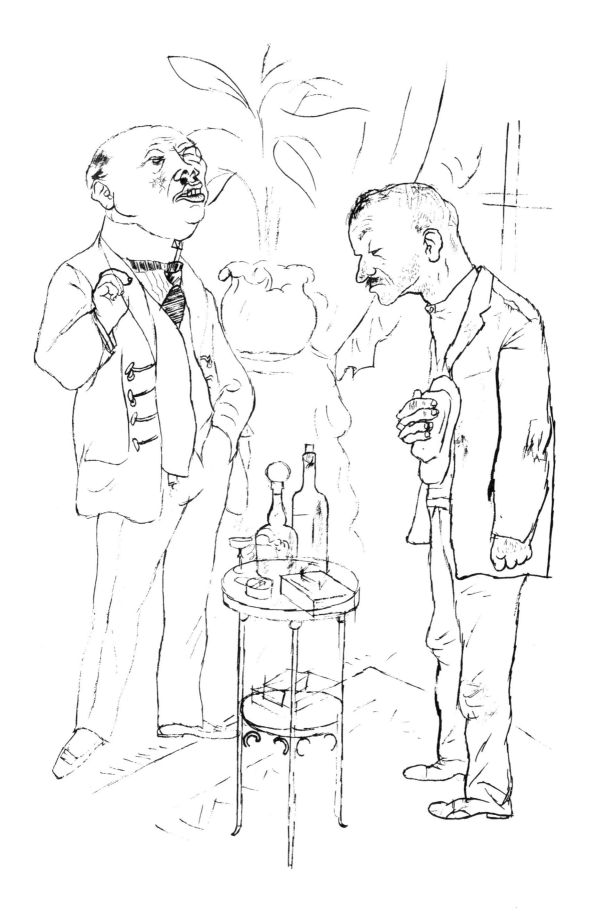

Getting the axe
Abbau

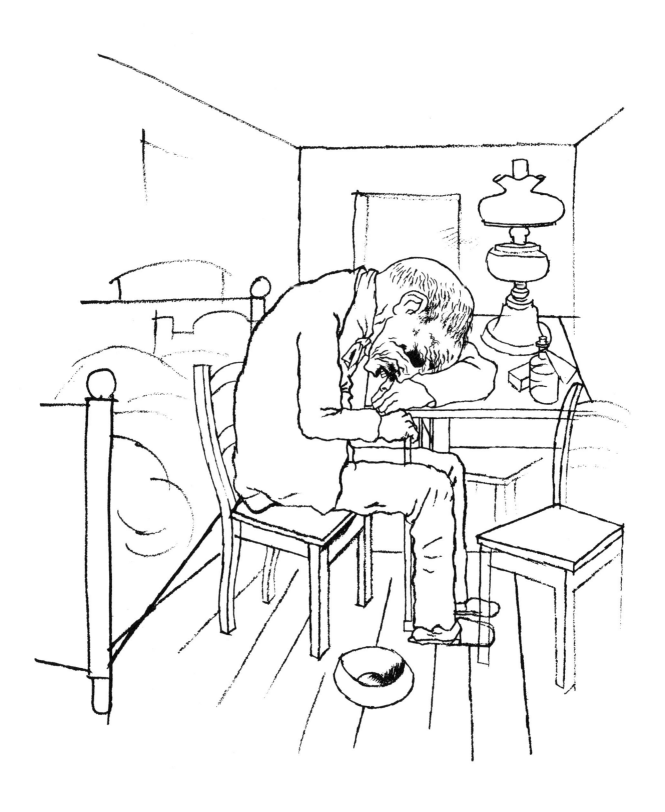

Victory of the machine
Sieg der Maschine

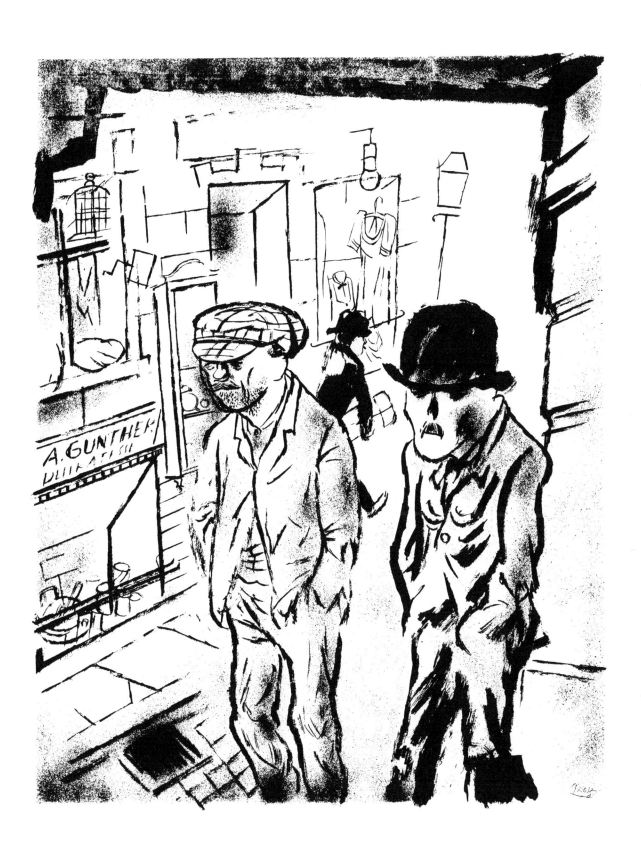

No working papers
Ohne Papiere

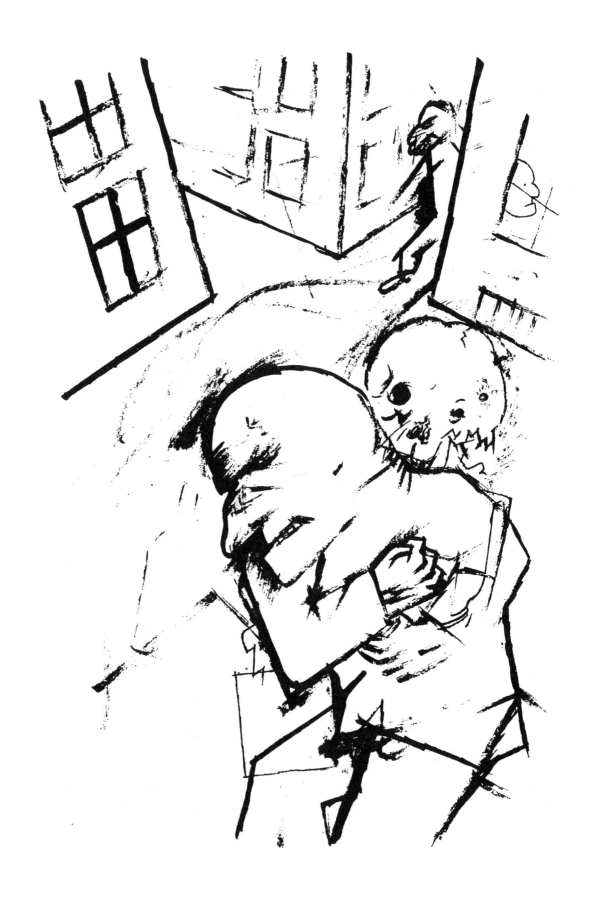

The end
das Ende

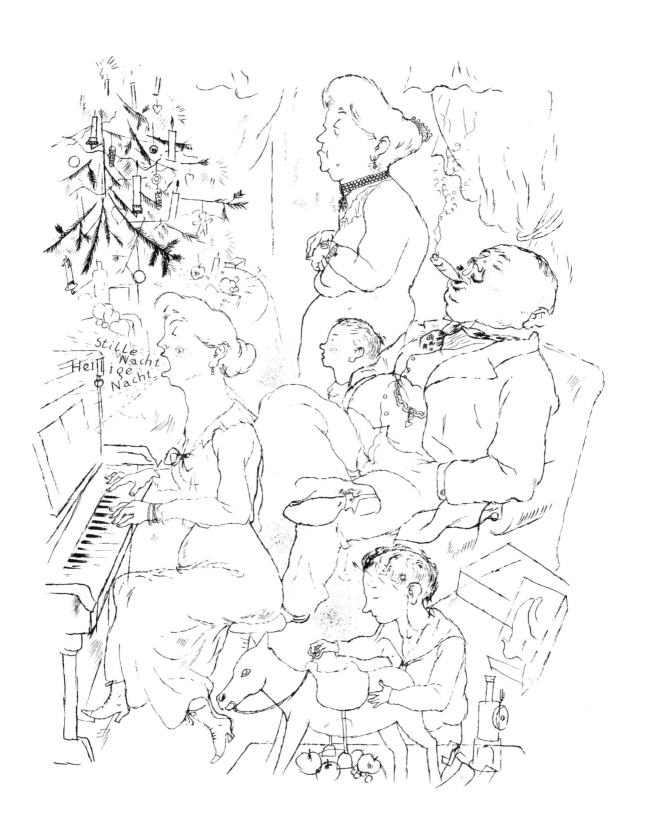

"God's visible blessing rests upon us": Schiller
"Gottes sichtbarer Segen ruht auf uns" (Schiller)

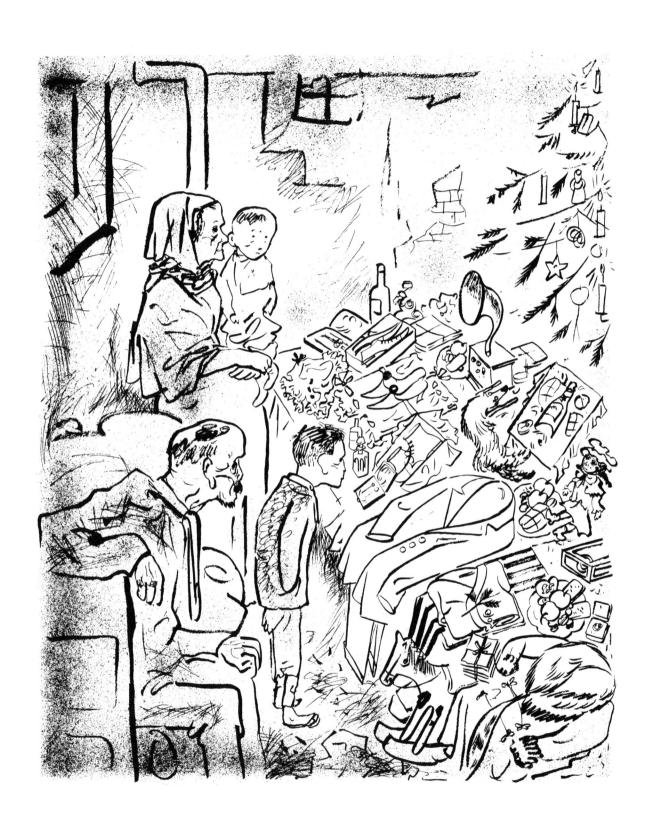

Fata morgana

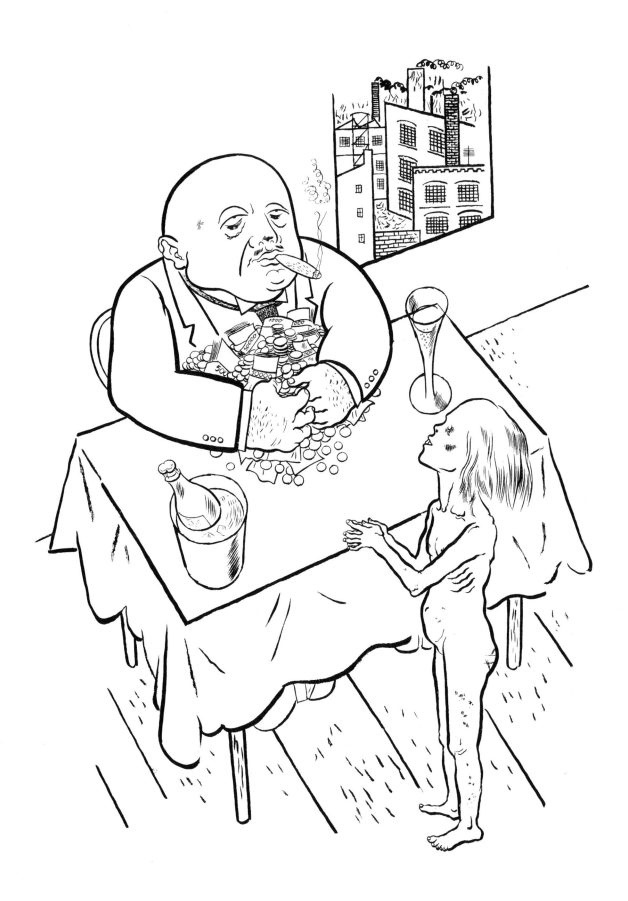

"Swim if you can and if you are too weak, sink": Schiller

"Schwimme, wer schwimmen kann, und wer zu schwach ist, gehe unter" (Schiller)

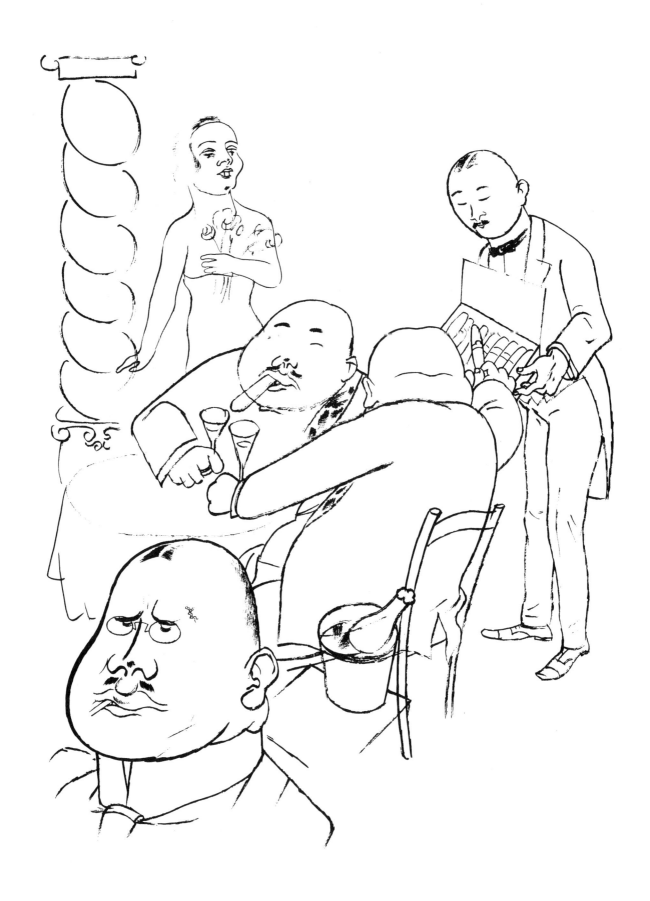

Grease rises to the top
Fett schwimmt oben

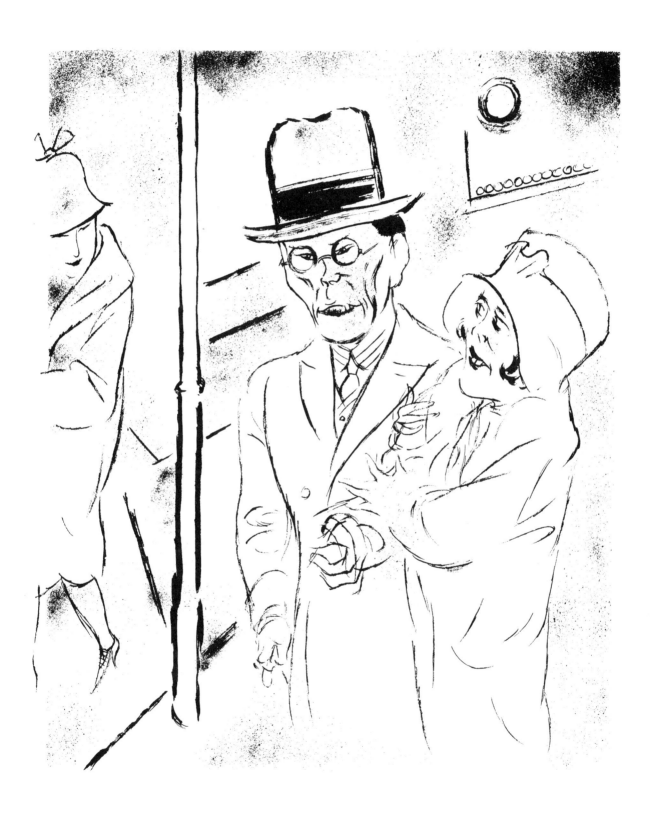

300 marks to the dollar
der Dollar 300

[A rate of exchange obtaining during the first half of 1922.]

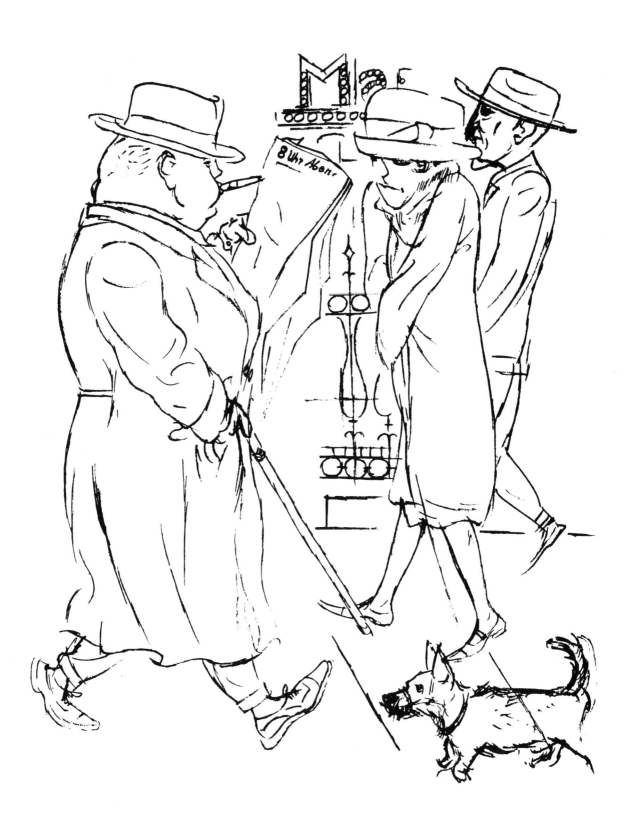

Bigger and better murders
Grössere und bessere Morde

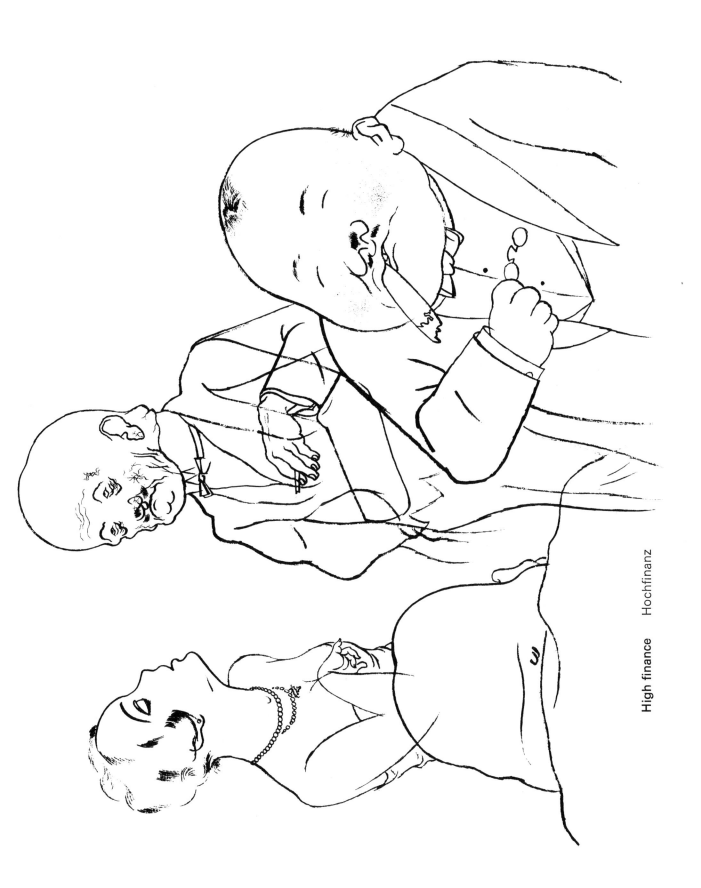

High finance Hochfinanz

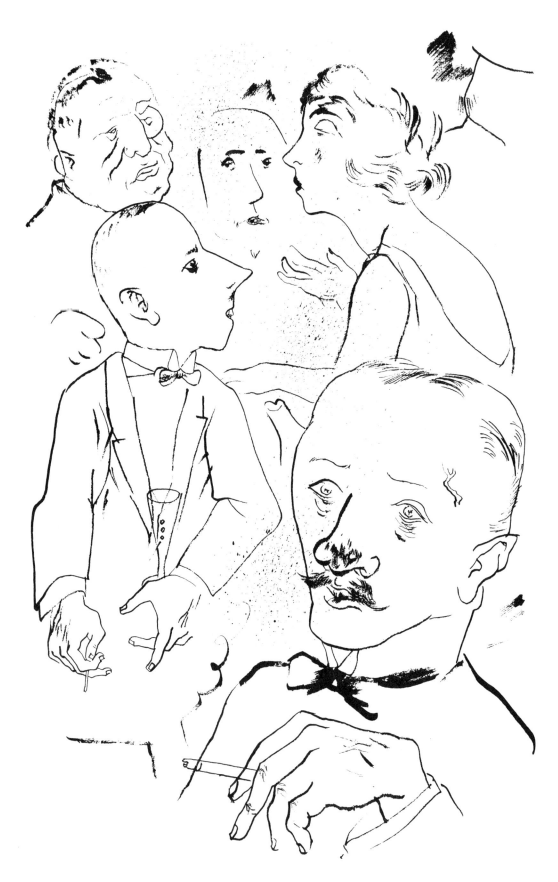

The younger generation
Nachwuchs

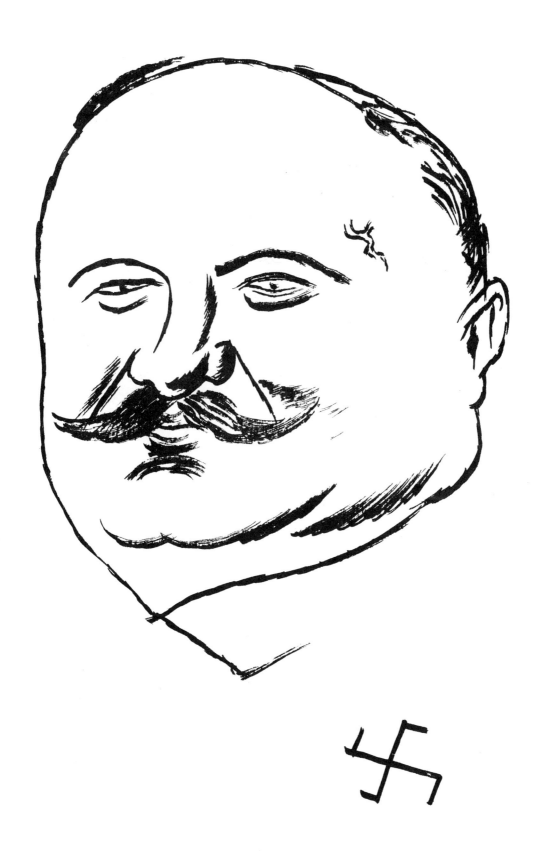

To be German means to do a job for its own sake
Deutsch sein heisst, eine Arbeit um ihrer selbst willen tun

[A slogan adopted by the Nazis; the man may represent a Junker who favored them.]

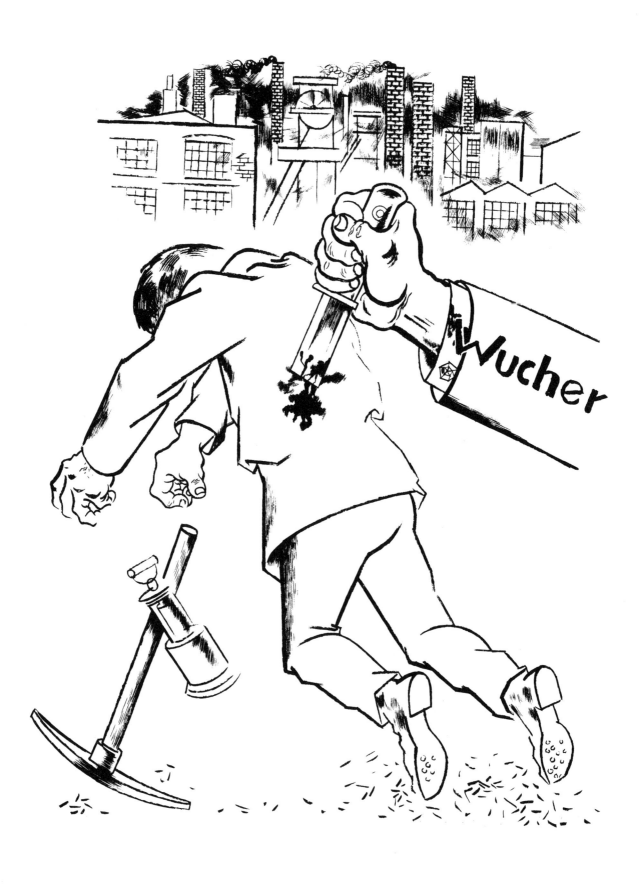

And the people bleeds constantly: the struggle for the Ruhr
Und immer wieder blutet das Volk: zum Ruhrkampf

[*Wucher* = profiteering.]

Little man
Kleiner Mann

87

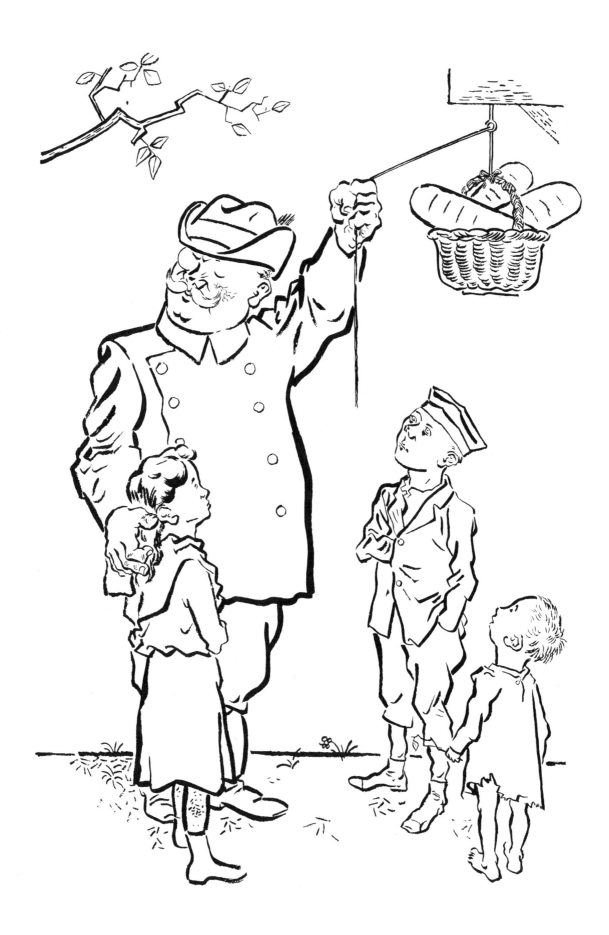

"Give us this day our daily bread"
"Unser täglich Brot gib uns heute"

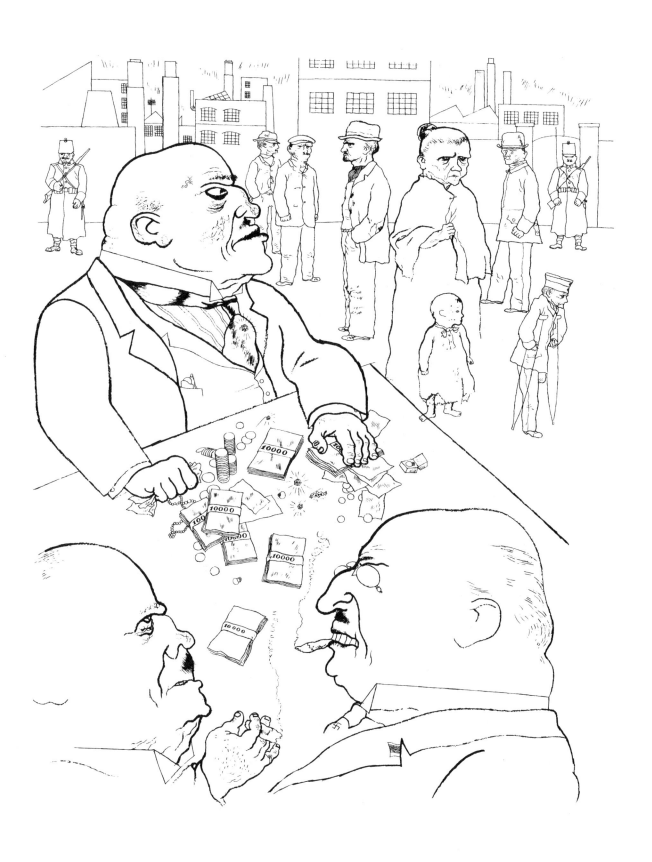

The willful possessors
Besitzkröten

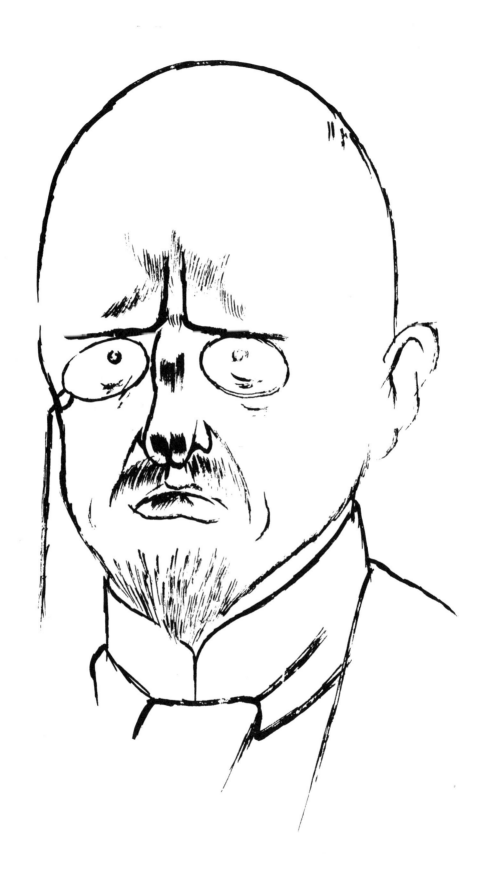

Black, white and red to the death
Schwarz-Weiss-Rot bis in den Tod

[The colors of the Imperial German flag, revived as the flag of the monarchist and anti-democratic forces under the Weimar Republic; the man may represent a reactionary schoolteacher or minister.]

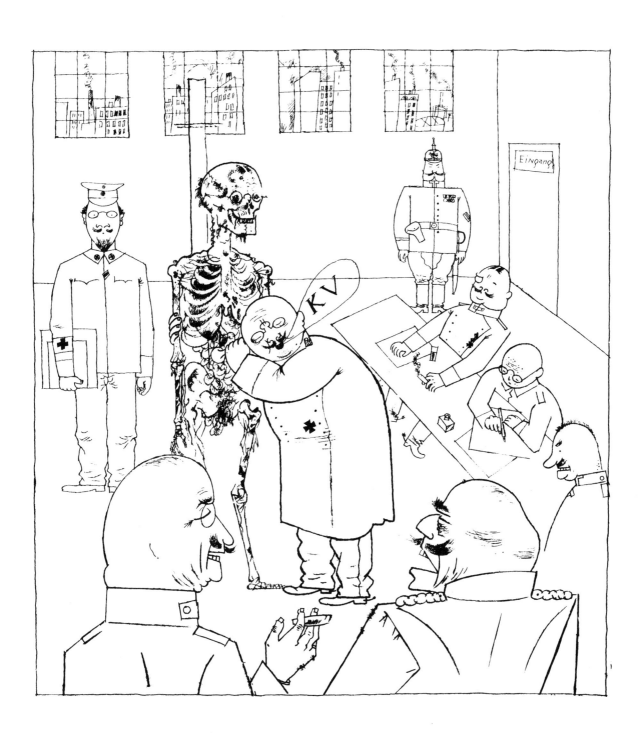

The faith healers
die Gesundbeter

[*KV* = *kriegsverwendungsfähig* = fit for active duty.]

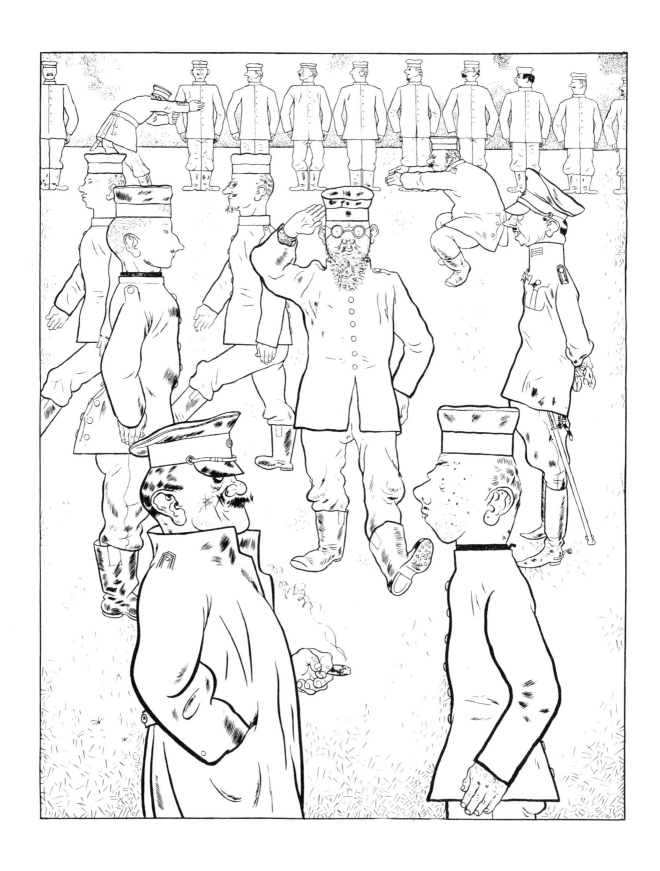

"Everything comes back again"
"Alles kehrt einmal wieder . . ."

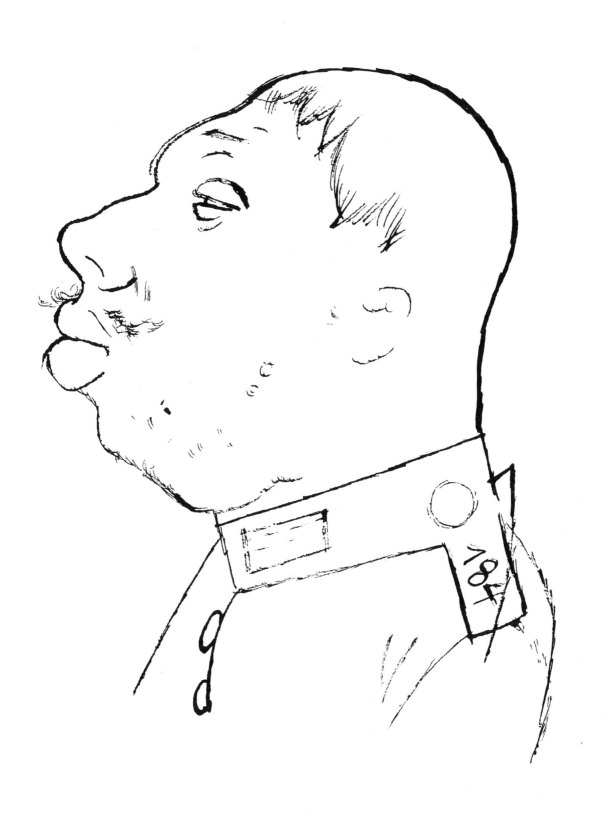

No one can copy this creation of ours
den macht uns keiner nach

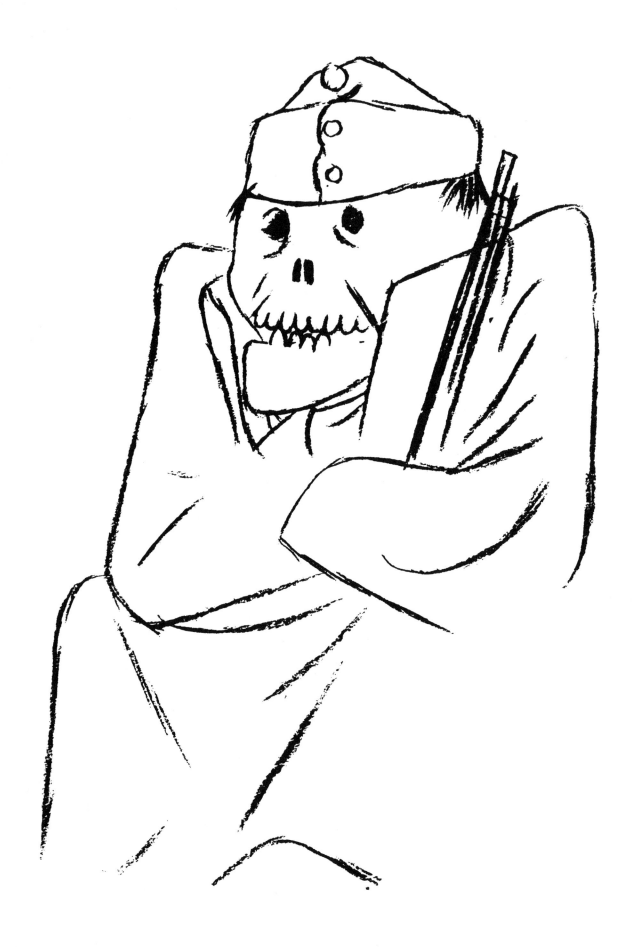

"No finer death"
"Kein schönrer Tod"

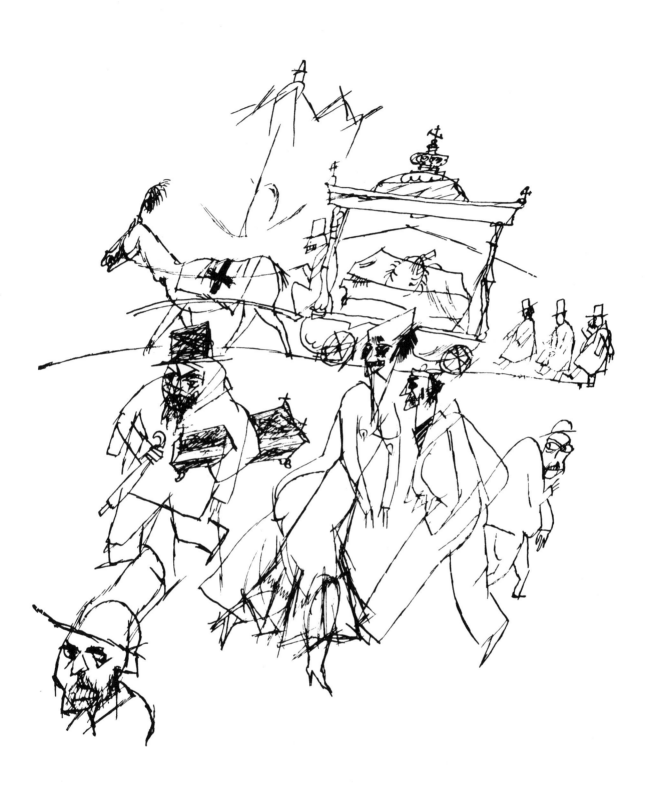

Stick it out!
Durchhalten

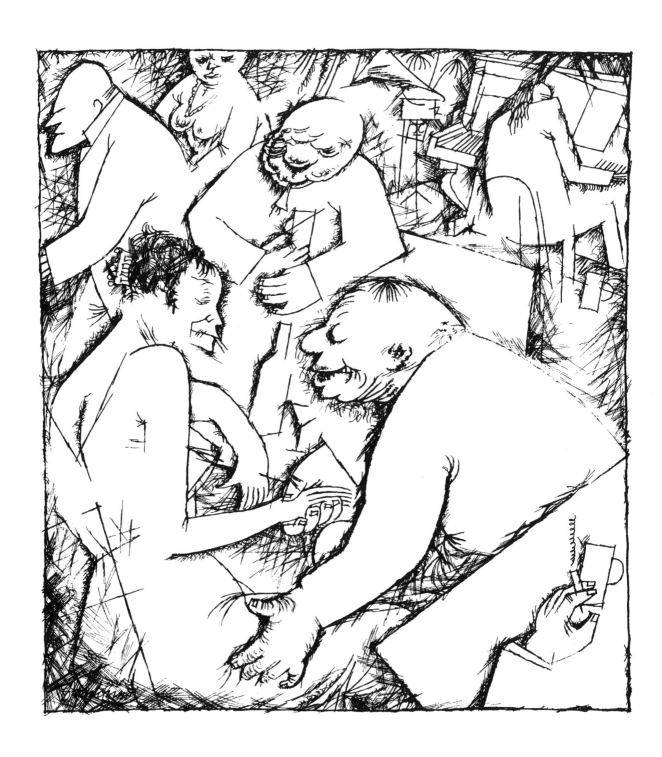

Escapade
Seitensprung

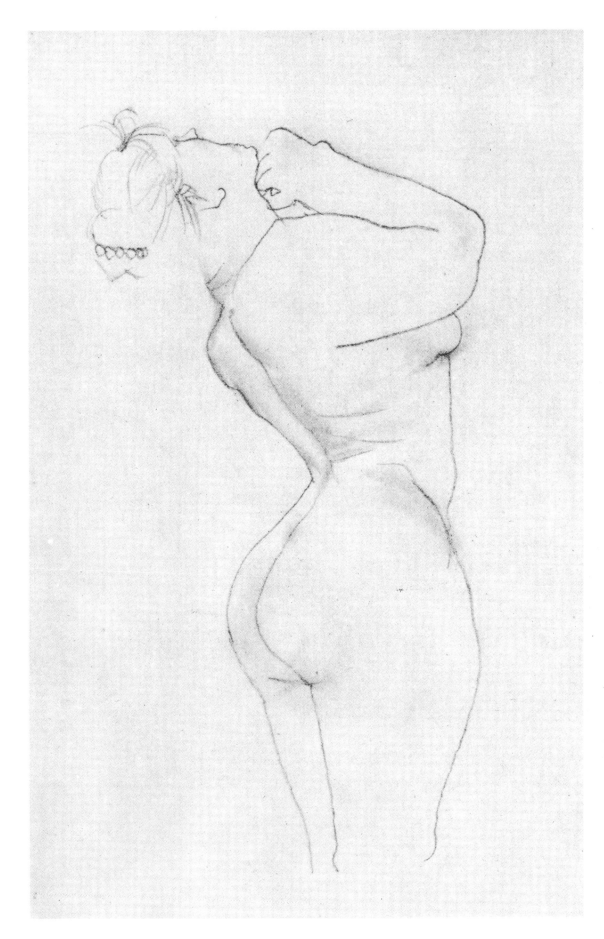

Female nude Weibs-Bild

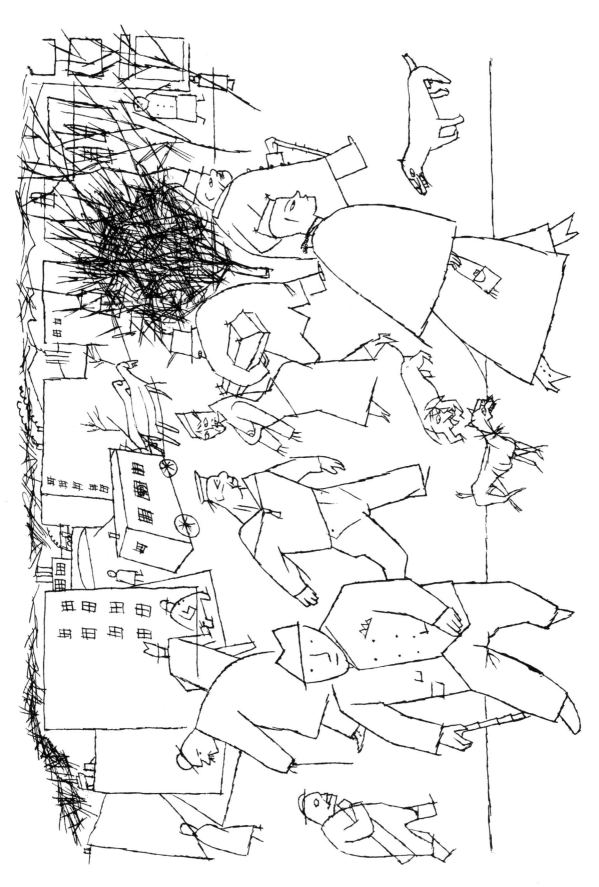

Round dance Reigen

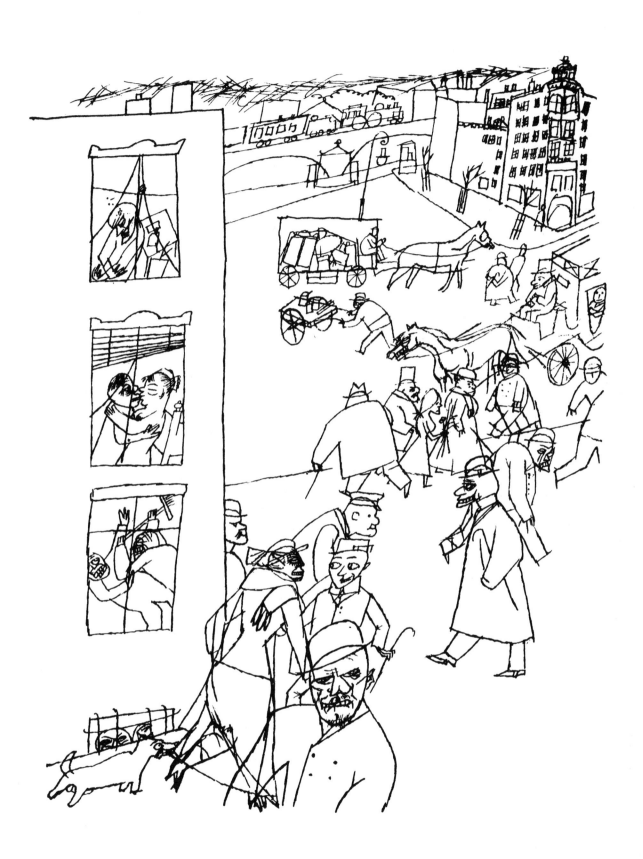

Human paths
Menschenwege

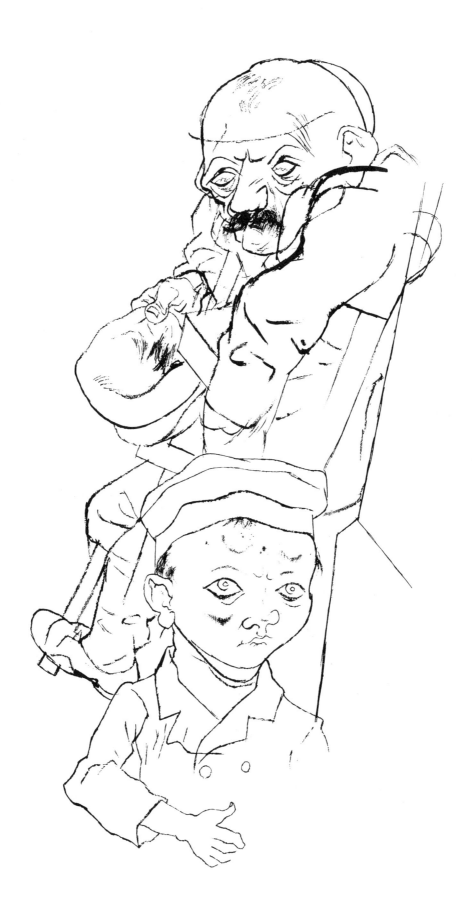

Old men
Greise

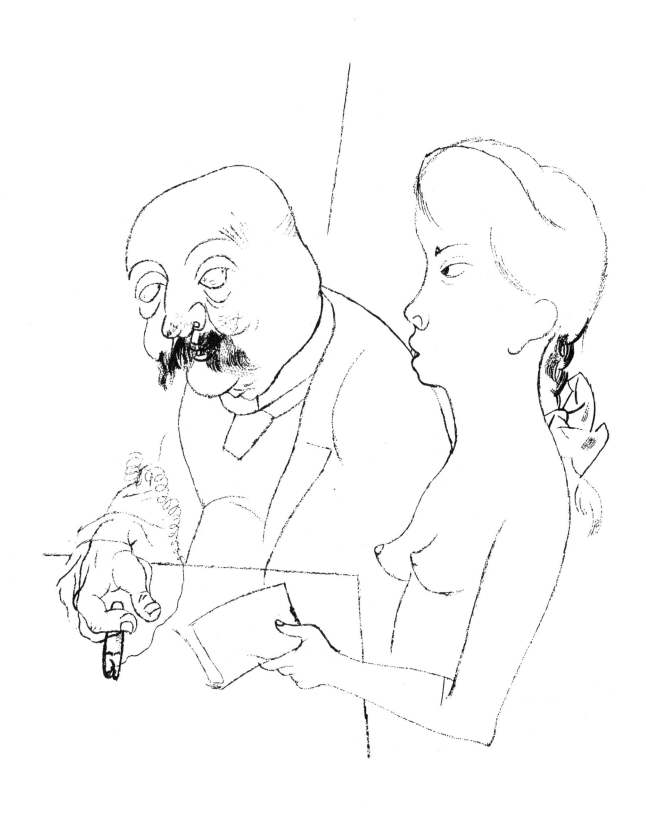

Awakening of spring
Frühlingserwachen

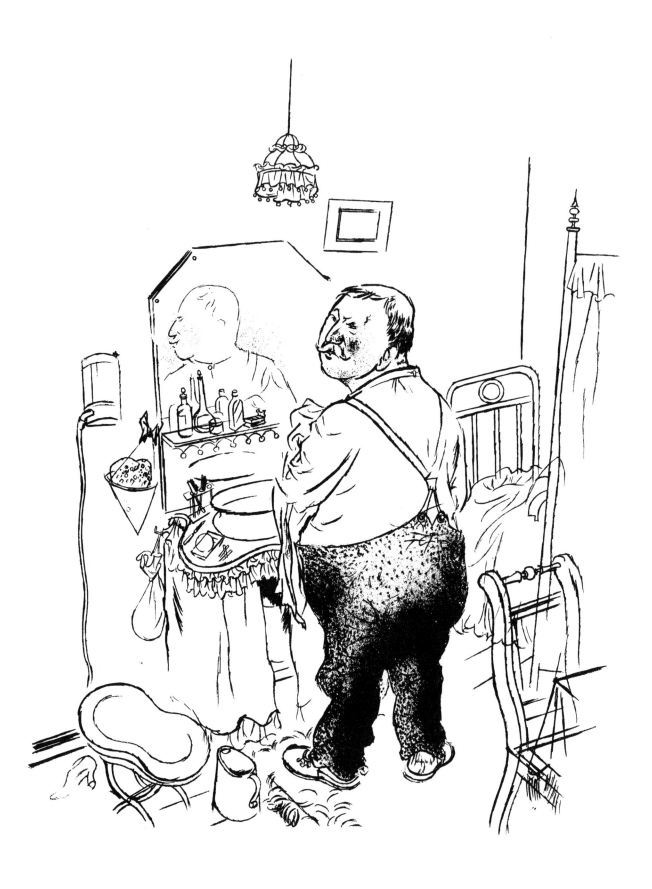

Widower
Witwer

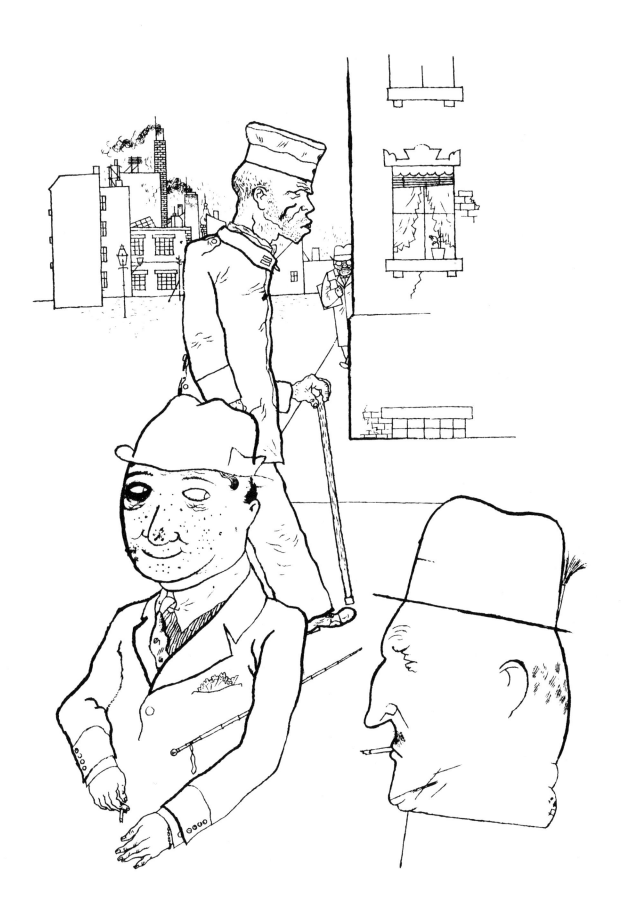

Inflation

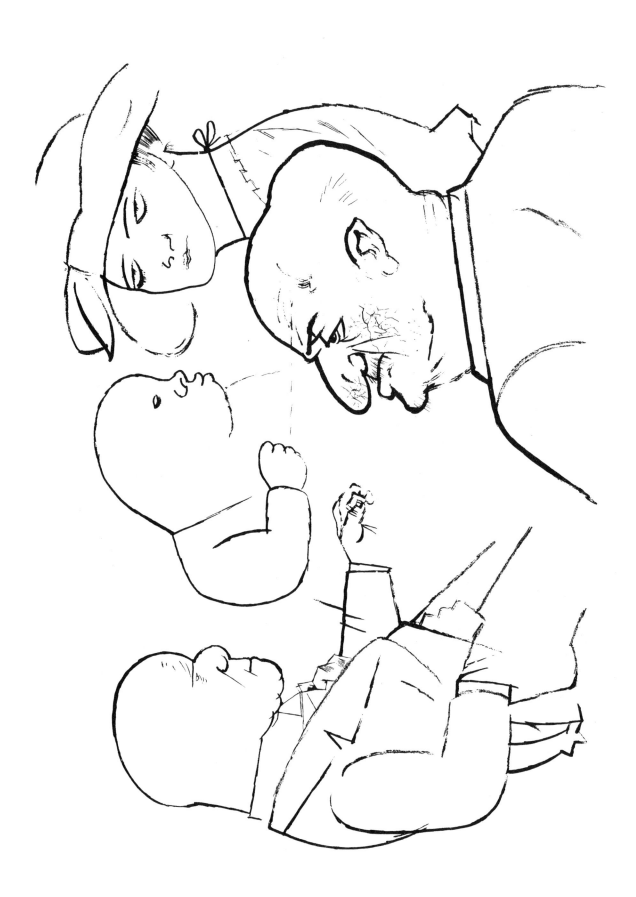

Sharks Haifische

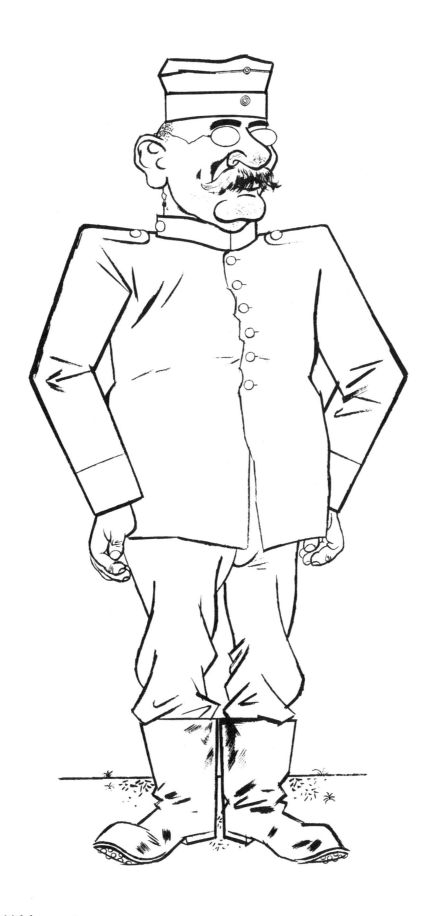

Noske, or A faithful servant
Noske oder Ein treuer Knecht

[Gustave Noske, politician who repressed uprisings in 1918 and 1919.]

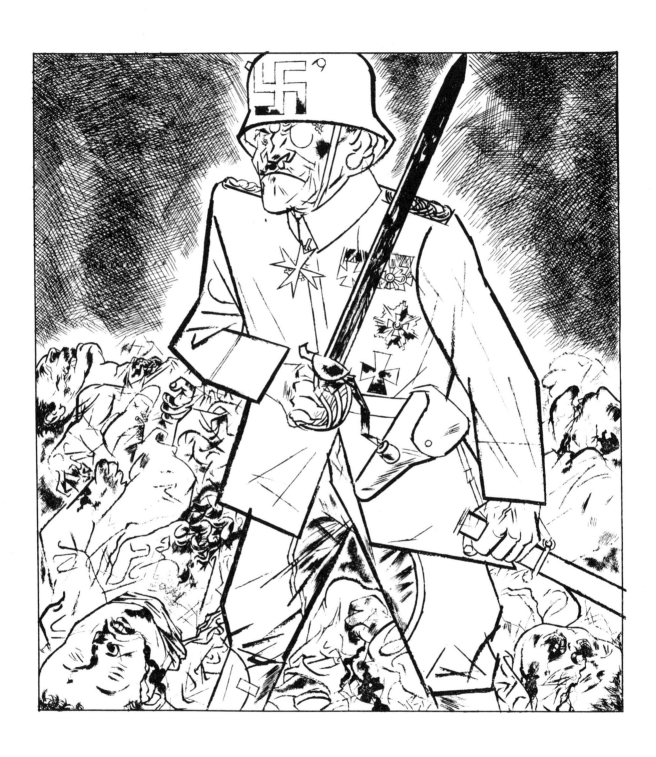

The white general
Der weisse General

[Symbolizing the anti-democratic militarists of the time.]

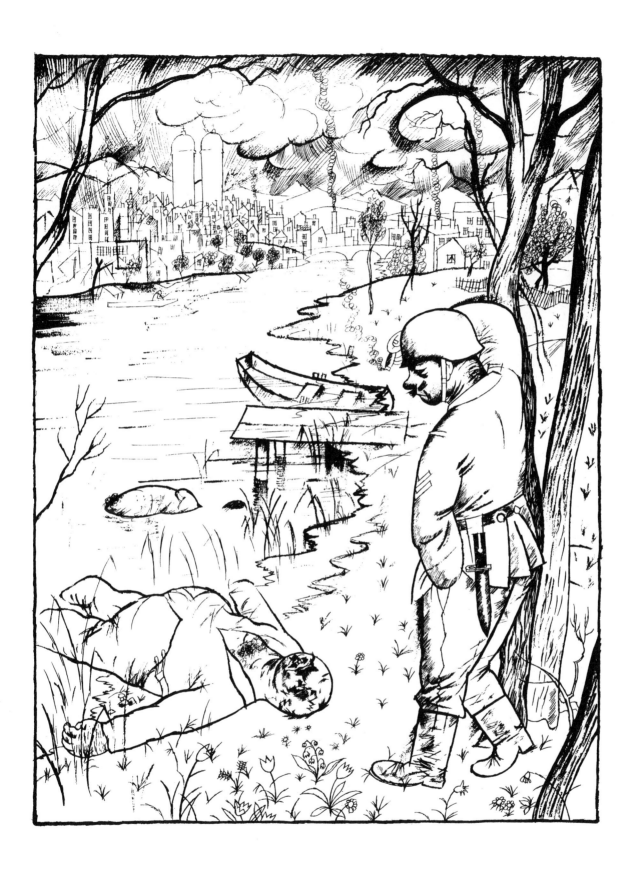

Free time after work
Feierabend

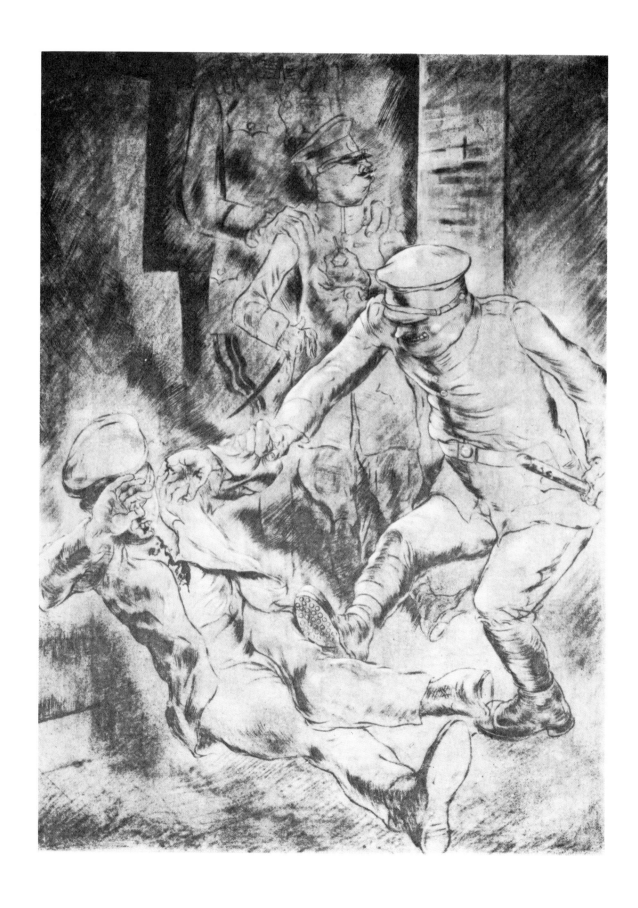

"Summary justice for traitors"
"Verräter verfallen der Feme"

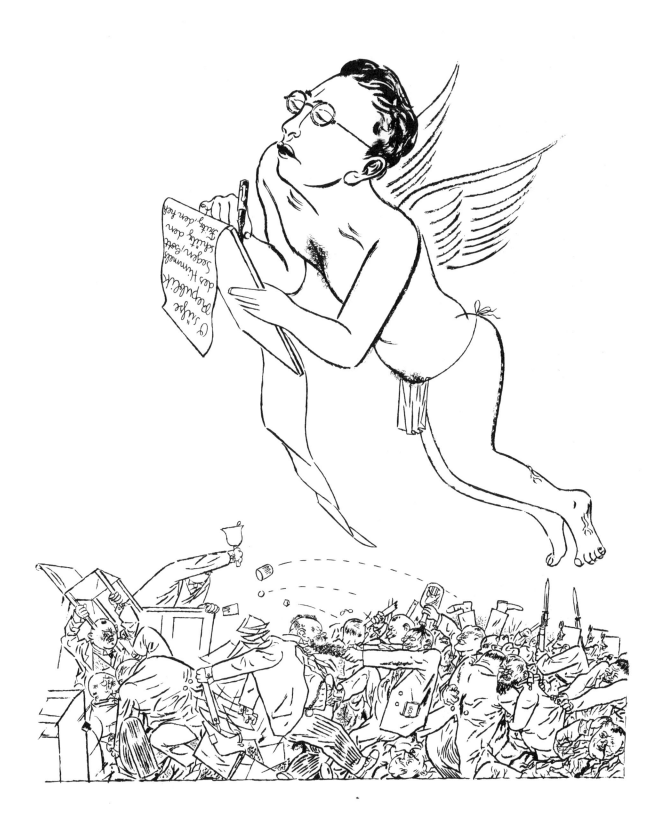

"The poet soars above party strife"
"der Dichter schwebet über den Parteien"

[The poet is writing: "O sweet Republic, blessing from Heaven; God protect Fritz, the magnif-"]

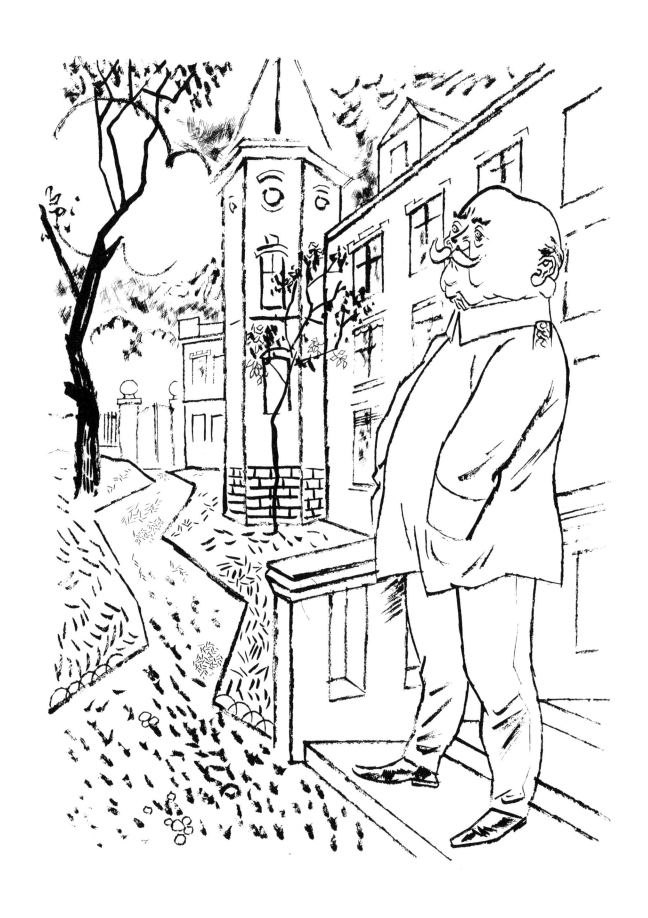

Pensioner of the Republic
Pensionär der Republik

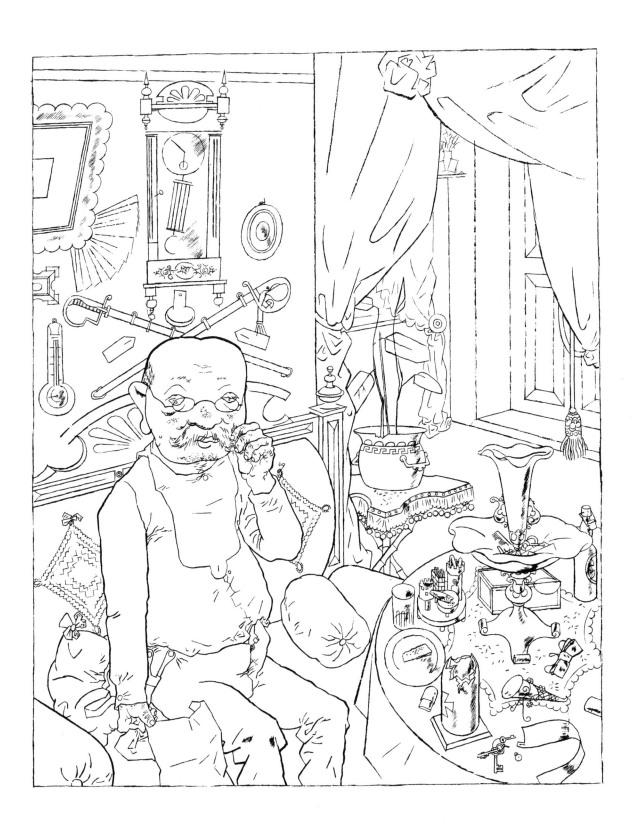

Old warrior
Alter Krieger

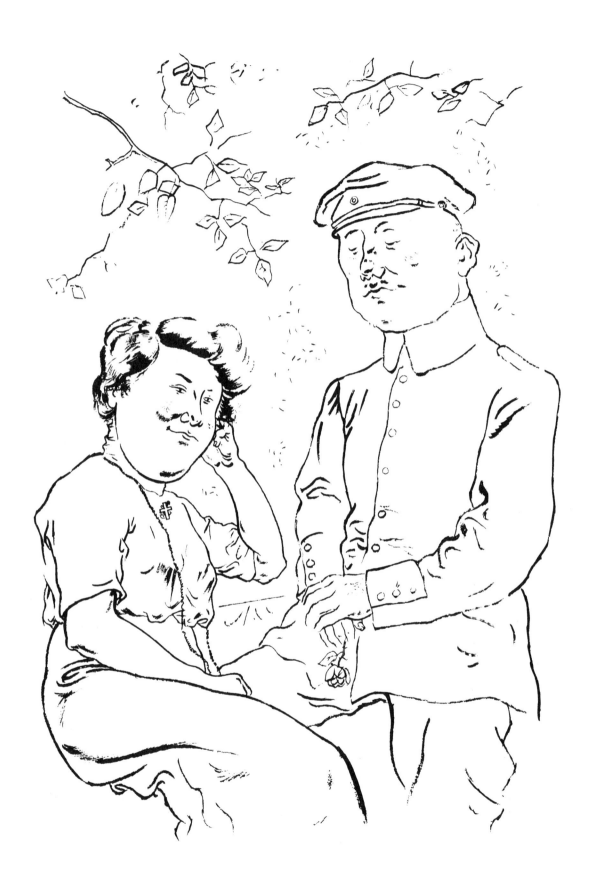

Maytime
Maienzeit

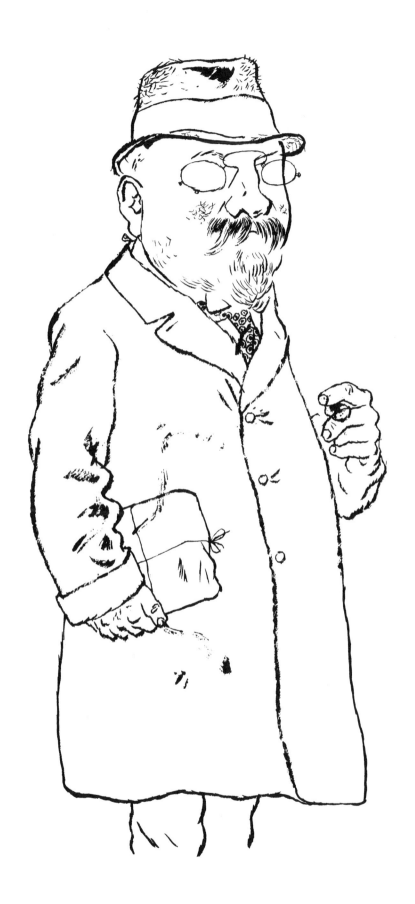

Oak
Eiche

[The oak symbolized Germany's strength and determination; the man may
represent a bureaucrat or hate-filled white collar worker.]

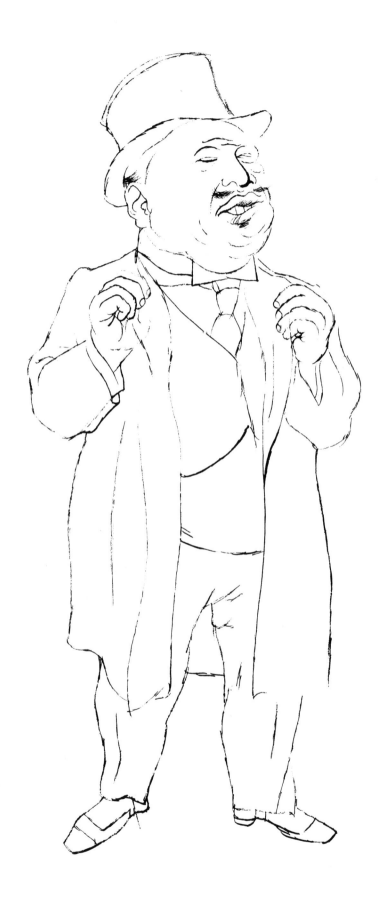

I buy and sell
Ich kaufe und verkaufe

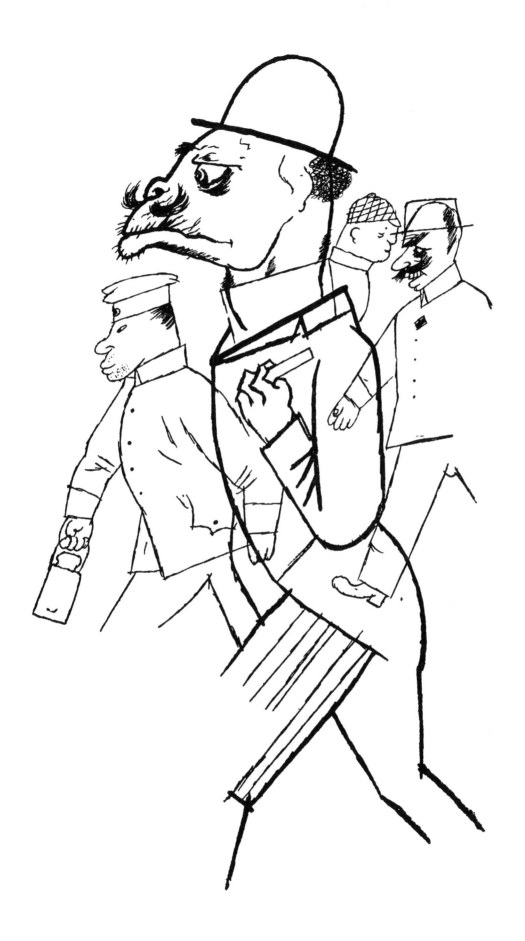

Beastly serious
tierischer Ernst

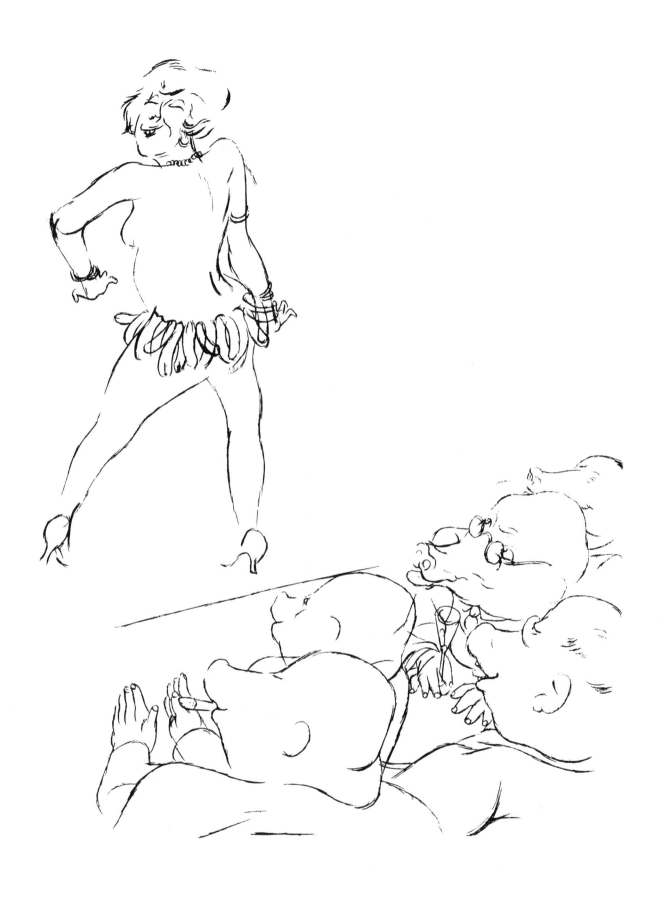

Call of the wild
Ruf der Wildnis

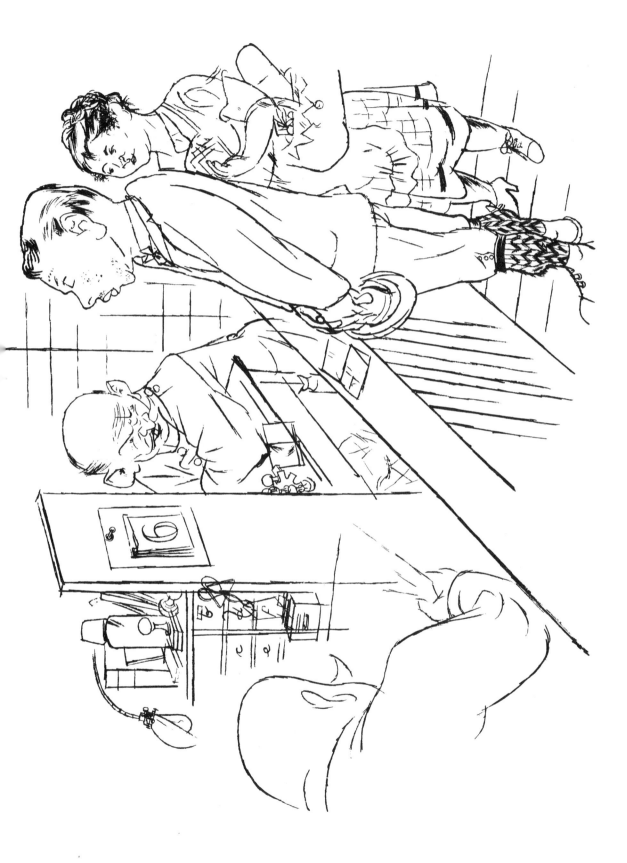

We must have order Ordnung muss sein

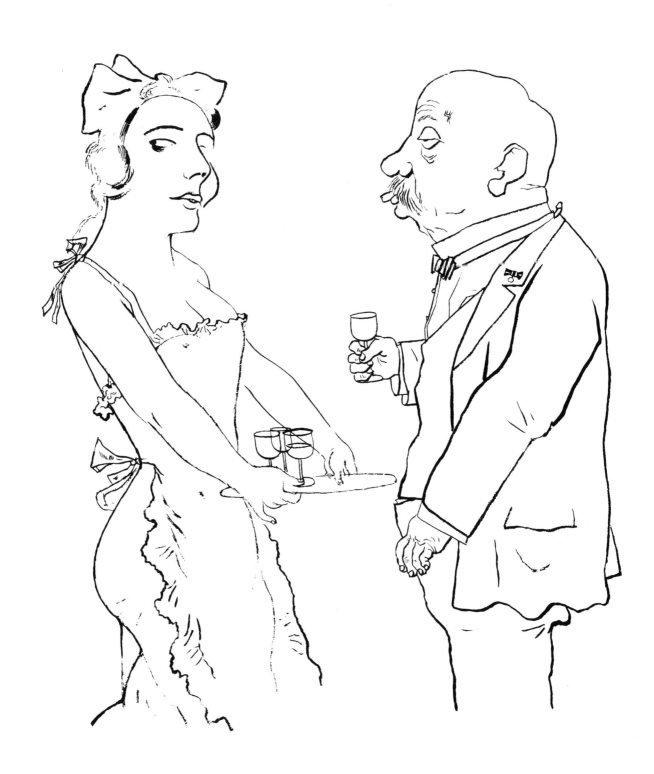

Grace and dignity
Anmut und Würde

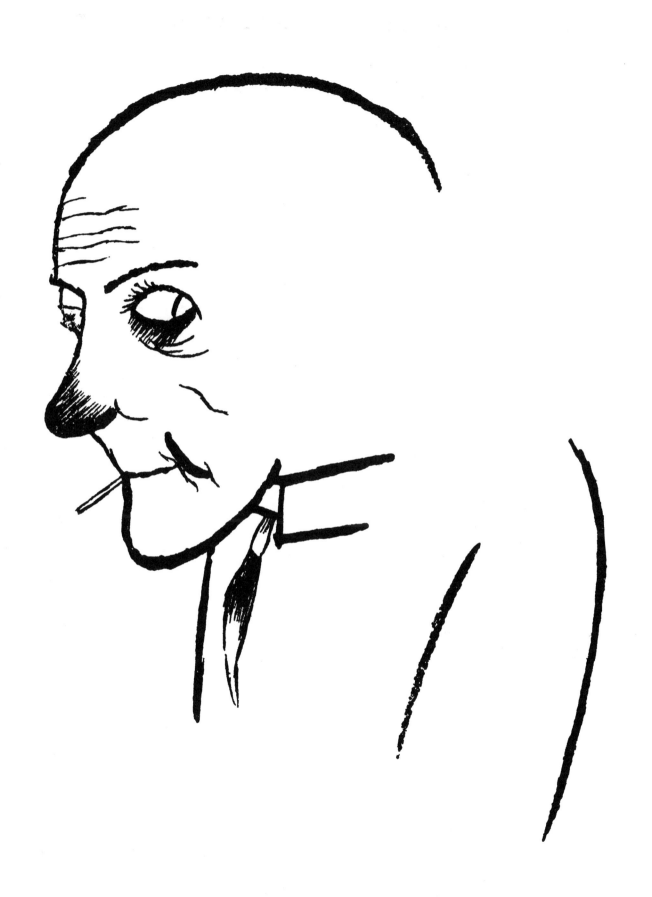

Guilty conscience
Schlechtes Gewissen